BASICS
CREATIVE PHOTOGRAPHY

Jeremy Webb

01

DESIGN
PRINCIPLES

Ethical: awareness/
reflection/
ion/
debate

academia

Design Principles

An AVA Book

Published by AVA Publishing SA
Rue des Fontenailles 16
Case Postale
1000 Lausanne 6
Switzerland
Tel: +41 786 005 109
Email: enquiries@avabooks.com

Distributed by Thames & Hudson (ex-North America)
181a High Holborn
London WC1V 7QX
United Kingdom
Tel: +44 20 7845 5000
Fax: +44 20 7845 5055
Email: sales@thameshudson.co.uk
www.thamesandhudson.com

Distributed in the USA & Canada by:
Ingram Publisher Services Inc.
1 Ingram Blvd.
La Vergne TN 37086
USA
Tel: +1 866 400 5351
Fax: +1 800 838 1149
Email: customer.service@ingrampublisherservices.com

English Language Support Office
AVA Publishing (UK) Ltd.
Tel: +44 1903 204 455
Email: enquiries@avabooks.com

ISBN 978-2-940411-36-8

Library of Congress Cataloging-in-Publication Data
Webb, Jeremy.
Basics Creative Photography 01: Design Principles / Jeremy Webb p. cm.
Includes bibliographical references and index.
ISBN: 9782940411368 (pbk.:alk.paper)
eISBN: 9782940439713
1. Photography ‡x Design. 2. Photography, Artistic. 3. Photography-
Study and teaching (Higher).
TR161 .W433 2010

10 9 8 7 6 5 4 3 2 1

Design: an Atelier project, www.atelier.ie
Cover image: Jeremy Webb
www.jeremywebbphotography.com

Production by AVA Book Production Pte. Ltd., Singapore
Tel: +65 6334 8173
Fax: +65 6259 9830
Email: production@avabooks.com.sg

Title: Dusk

Source/Photographer:
Jeremy Webb

An effective design often results
from an approach that trusts in
limitation as a creative driving
force behind the process of image
creation – doing more with less.
Once one or two separate elements
are isolated and emphasized, the
transforming nature of light can
effectively and dramatically blend
these elements together.

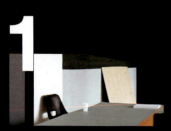
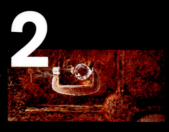

Contents

4

5

6

7

The idea of studying design principles in photography can sound a little off-putting – much like the tedium of learning scales when starting to play a musical instrument. This book will hopefully remove that kind of negative association and show how photography underpinned by the power of design principles is photography that has the power to last and affect us deeply. Design plays a vital role in turning images into long-distance runners, not simply sprinters.

Our resistance to design principles partly lies in our attitude and approach to design in the widest sense. We've simply become immune to design's overwhelming effect on our daily lives. From the moment we wake up and hurl our alarm clocks to the floor, to the moment we close our eyes and turn off our digital radios, our days have been filled with well-designed furniture, cars, magazines, packaging, town planning and so on. Most of it works, although much of it doesn't. But design always promises something – mostly, the idea that it is intended to make our lives a little better.

It could be argued that design principles make our photography a little better. However, this is a feeble underestimation of their usefulness to photographers or lovers of photography. Rather than existing as a strict set of unchallengeable rules or guidelines, design principles applied to photography can act as a kind of fluid, flexible and unseen nervous system that brings images to life. Some great photographers naturally have the wisdom and insight to work with design principles. However, not all photographers share this talent. Luckily, it is a skill that can be learned and developed to create memorable and lasting images.

The continuing rise of digital culture has reignited interest in the world of photography as a mass art form, and new channels of distribution have opened up to send billions of photographs spinning across the globe at a bewildering rate. It's not simply the technological new age that facilitates this volume and speed of image distribution – our collective mindset and greed for speed also grease the engine. The world is simply crammed full of photographs like never before.

This appetite for photography, however insatiable, is still hungry for photographs of substance, craft, meaning and powerful intent, despite an overwhelming landslip of the mediocre and mundane. What makes photographs endure? A photographer who calls upon his or her sense of design, and delivers with style and vision, sends images out there that are worlds apart from those generated with mere speed and convenience in mind.

An understanding of design doesn't slow you down, trip you up, or stand in your way. It is a skill available to everyone at all times and unless we reach out and grasp the full potential of the medium, photography just sits and runs in 'sleep mode' when it should be life-affirming, vivid and impossible to ignore.

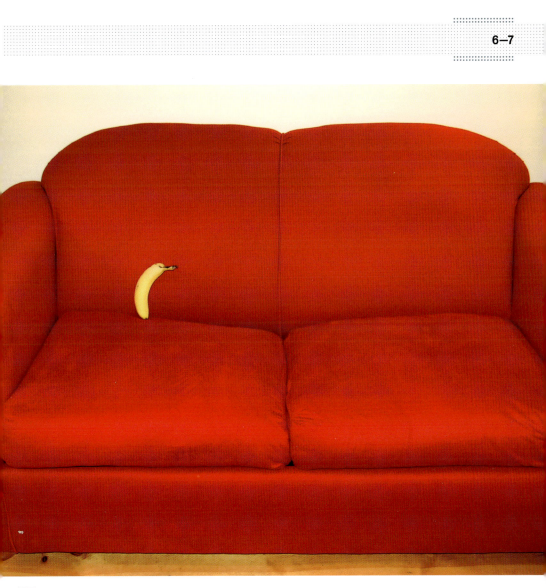

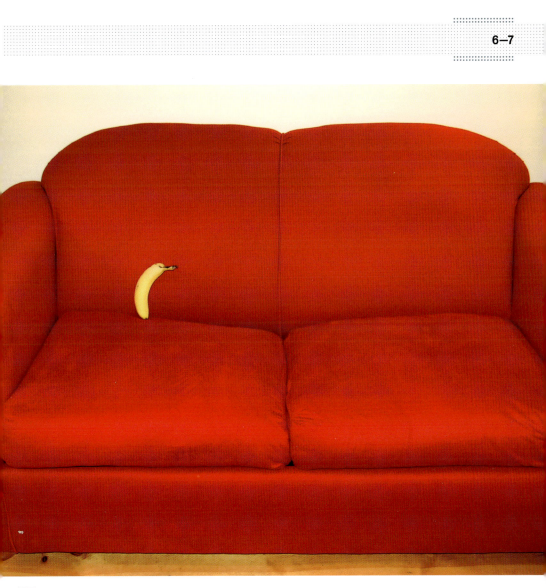

Title: Red sofa and banana

Source/Photographer:
Jeremy Webb

Design awareness enables photographers to see potential in situations that are not apparent to others. It improves your photography and increases your ability to see the world differently by understanding how even the simplest scene can provide opportunities to be playful with the principles of design.

Basic design theory

The opening chapter takes a close look at a few of the most important steps in the process of photography – how you frame your subject and where you take your photograph from. Decisions over distance, angle and viewpoint can profoundly affect the overall appearance of the final image, and the use of space within photography can give life and substance to your subject, influencing how we 'read' photographic images.

The elements of design

These elements are widely considered to consist of six design features or characteristics that photographers can utilise within their picture-taking to create images powered by vision and creativity. Like raw ingredients ready to be powerfully combined by the design process in the following chapter, we'll take a look at each one in turn and evaluate how they can be used as aspects of composition.

First design principles

Having looked at the raw ingredients or elements of design in the previous chapter, this critical section of the book shows how the elements of design can be processed, combined and manipulated to create powerful images that have design at the heart of their appeal.

Depth and scale

All photographs are two dimensional, but this doesn't have to limit our thinking or our intuition. The use of design principles can create the illusion of depth and this can influence our involvement within the image. We'll look at how proportion and scale can confuse and delight the eye, and how the art of the abstract is derived from an awareness of simple but essential design principles.

Movement and flow

When photography appears too static or limp, it's often because the image contains no real sense of motion. Motion means life. A sense of movement can bring an image to life with powerful directional forces that demand an active engagement with the image rather than a passive acceptance. This aspect of photography can be easily accessed through the use of dynamic design.

Emphasis and emotion

To a large extent, successful photography relies on the ability of the photographer to construct his or her image so that its audience will respond to the same point of interest (POI) or feel the emotional response the photographer intended. This chapter looks at how the use of colour, focusing and a range of compositional techniques subtly or profoundly influence our emotions.

Putting it all together

What good is all this knowledge if it simply remains theoretical? Applying design principles to your work puts you in charge of the whole picture. We wrap things up in this chapter by looking at symbolism, presentation and a range of ideas to help keep design at the heart of your work.

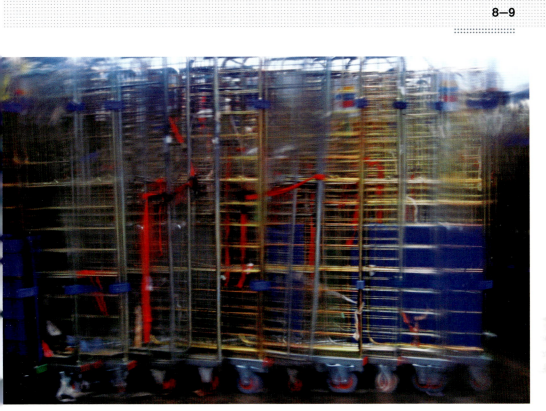

Title: Trolleys

Source/Photographer:
Jeremy Webb

The mundane sight of supermarket trolleys is given a different twist by shooting through a rain-soaked car window. The vivid blues and reds of the webbing straps have softened and bled almost like watercolour paints on paper, providing a softer and less distinct image of the everyday.

Applying design principles to your work puts you in charge of the whole picture.

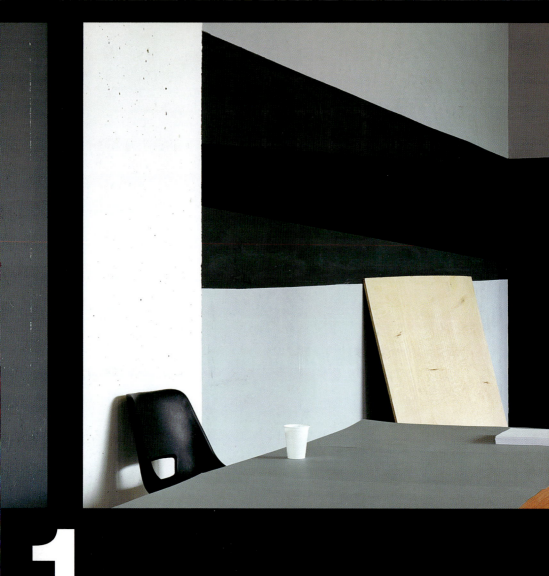

1

Basic design theory

Title: Gallery

Source/Photographer:
Hannah Starkey

Within this beautifully constructed image, so reliant on straight lines and blocks of different tones, only the plastic cup and the plastic chair stand out as isolated elements within the angular and very graphic study of the space.

At its most basic level, design applied to photography is simply the skilful arrangement of picture information within a frame. Photographers can include or exclude information, emphasize or diminish areas of content, and adjust their position by a fraction of a degree if necessary in order to capture the image required.

Design and composition are like two sides of the same coin – design being the process and composition being the outcome. Acknowledging and responding to the role design plays within your photography enables you to create images that can be 'read' and understood by the viewer. However, it is crucial that the gaining of this knowledge does not in any way destroy the magic of photography or detract from its power.

Many photographers agree that, there is no winning formula or easy route to consistently producing good photographs, if a *good* photograph is held to be one that is clear in its intent and strong in its composition. It's really a question of juggling with a set of design variables and being able to see what is really there, not what we might expect or assume to be there. Once we can approach a subject with an uncluttered vision and a childlike curiosity, we have the opportunity and the motivation to capture an image with the uniqueness of our own vision and the greatest efficiency required.

The viewfinder creates a precise boundary between what's captured and what's not. Unlike painting, where an image begins with a blank surface, photography can be called a reductive pursuit. It starts out faced with *everything* and it extracts a minute aspect of that by using the viewfinder edges to consciously or unconsciously create a *something* by excluding specific elements.

Here, the term 'reductive' is not used in a negative sense, but rather it highlights the essence of photographic image capture in the way it is normally practised.

The viewfinder is the greatest compositional tool known to photographers. However, its power to influence our engagement with images is often poorly considered because we are too concerned with subject and centrality rather than imaginatively framing a scene in innovative or extraordinary ways.

After our imagination and our creative expectations, the viewfinder is where we first encounter the design process at its most raw. How the viewfinder frames our intended subject is based on a range of decisions taken by the photographer, the most critical factors behind these decisions being height, angle and distance to subject.

The edge

Using the viewfinder's full capability allows the photographer to consider 100 per cent of the image space available, right up to the edges. As an intentional choice, using the viewfinder edge to visually dismember a subject or cut off something into nothing has both positive and negative consequences. There is no escaping the fact that an image has to have some kind of boundary, but that does not mean we have to take a passive approach to its inevitable restrictions. We must look for opportunities to use it creatively.

Some photographers are acutely aware of the power of the defining edges of the viewfinder; their images creatively play with what is included or excluded from the photograph.

By using the viewfinder consciously and effectively, photographers can create bold and compelling images that frame the world in unusual ways. In addition, they enable the viewer to address a familiar subject matter through a new perspective, while emphasizing and reconfiguring the various design elements into fresh arrangements of greater visual appeal.

By using the viewfinder consciously and effectively, photographers can create bold and compelling images that frame the world in unusual ways.

Title: Frosty bird hide

Source/Photographer:
Jeremy Webb

In this image, the viewfinder was used to frame a portion of the wider scene into a harmonious and balanced composition by blending shape, texture and tone contained within the boundary of the viewfinder.

Title: Snow wave

Source/Photographer:
Jeremy Webb

Sometimes nature lays the simplest forms right in front of us. By using your judgement of distance, proximity and viewpoint, you can let the frame take over and bypass all that is unnecessary for an exercise in simplicity.

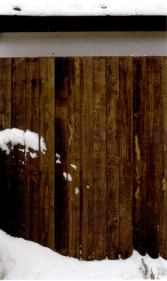

The frame: whole truths and half truths

Photography can never present the whole truth, but it can shape history because of the notion that photography is bound up with truth. For example, world events have been initiated, recorded and sometimes turned around by the influence of photography in news journalism.

A famous TV advertisement created in the 1980s depicted the scene of a skinhead walking down a street, before breaking out into a run and heading straight for a little old lady. The message was clear: here was a menacing and dangerous individual out to rob or beat up a defenceless victim in broad daylight.

As it turns out, the film reveals the man is running towards the lady in order to knock her out of the way of some scaffolding about to fall on her. The carefully controlled filming and framing of the scenes plays to our prejudices and only tell part of the story at first. After a dramatic pause, the full facts of the scenario are revealed and the whole truth is presented. The advertisement shows that the frame can capture part of the scene to create one carefully contrived meaning, while taking an alternative view presents another.

Although a situation can contain multiple meanings and points of view, it's the photographer who selects which interpretation of a scene he or she will retain for further editing or presentation. With this power comes a responsibility to deal ethically with potentially controversial subjects and situations, and on a more artistic level, to use the viewfinder (and subsequent compositions) to squeeze the most creative value out of the subject in front of us.

Inclusion vs exclusion

Deciding what you should and shouldn't include within your frame presents not only moral dilemmas, but also design issues about whether what you include benefits your image or detracts from its overall power.

Ideally, what you frame within your viewfinder should only contain the detail and substance necessary to communicate your vision as powerfully as possible. The greatest photographers get to the heart of something or someone in a way that leaves amateurs envious because they have developed an intuitive ability to get close to their subjects or to use their sense of design (in terms of arranging the elements within the viewfinder) to carefully exclude unwanted detail or to emphasize certain components at the expense of others.

The inclusion of unnecessary or distracting details will allow your audience to miss the point or become troubled by the sheer number of possible interpretations and responses that could arise from a cluttered or busy image.

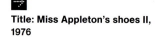

Title: Miss Appleton's shoes II, 1976

Source/Photographer:
Olivia Parker

Olivia Parker creates beautiful compositions with her still life images. In this image, the scene is contained by a black border, which is created by the edge of a processed sheet film that also references the photographic nature of her images.

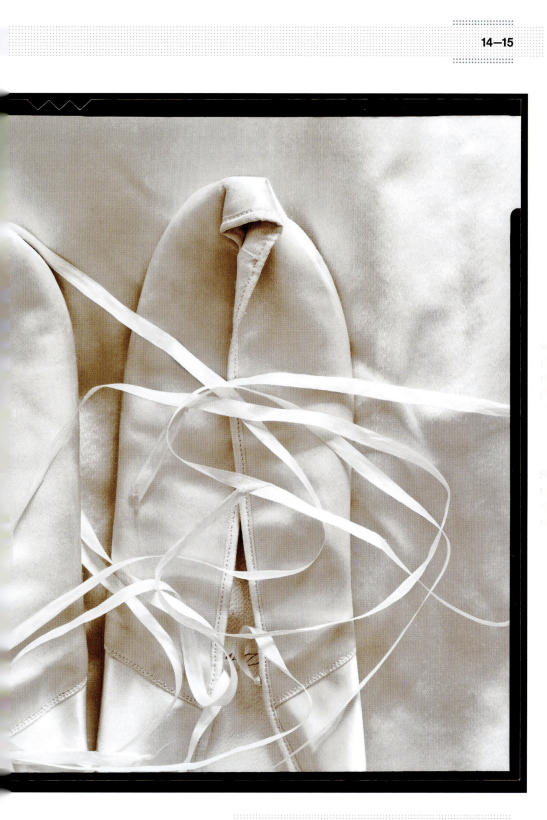

Ike Turner once said:

> *'It's the spaces in between the notes that are important'.*

Space is every bit as important as substance – it is substance as far as design is concerned. Within design, space can be used to isolate something; to throw emphasis on something; to provide contrast against something; and to show the scale and scope of a subject, among a thousand other uses. Its presence is just as visible within an image as any tangible subject that may emerge from it.

Awareness of space

Awareness of space as a design principle allows you to confer emphasis on a subject, or create stronger separation between a subject and its environment or background.

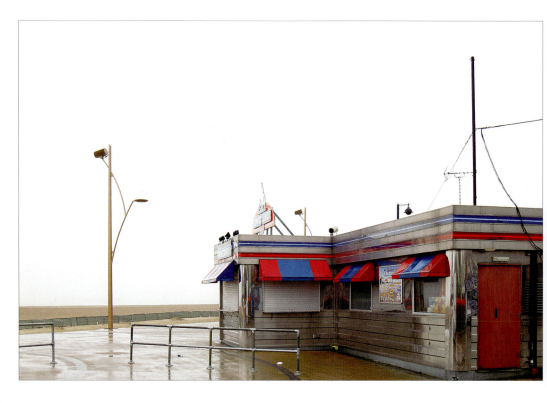

Positive and negative

Many simple optical illusions rely on the eyes' perception of space for their effect. Space can define where an object lies in relation to others, and thus allow us to make sense of a scene or situation. Many illusions exploit our habit of assuming that dark or black areas of tone represent subject, while light or white areas equate to the absence of subject – emptiness or space.

Photography, too, can play with these assumptions. After all, the eye makes sense of a flat two-dimensional image and accepts it as a facsimile of the three-dimensional world almost without question.

Using space as a design tool enables us to manufacture depth, and depth takes us just that little bit nearer to closing the gap between the frustrations of two-dimensional representation and the three-dimensional experience of life being lived. The gap is still vast, but at least it's going in the right direction. Depth, in terms of photography, allows us to peek beyond the conventional limitations of two-dimensional imagery and creates a vicarious version of experiential reality.

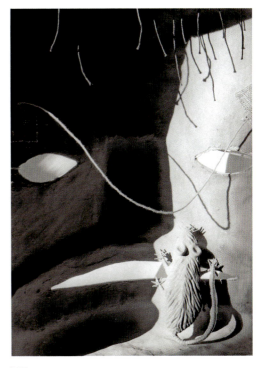

Title: Mask

Source/Photographer:
Oleg Dersky

The creative use of negative and positive space enables photographers to play with our perceptions of what appears to be coming forward and what appears to be retreating. The full craft and construction behind Oleg Dersky's image only reveals itself when we peer beyond the surface presentation of the image.

Title: Burger café

Source/Photographer:
Jeremy Webb

By positioning the burger café within the lower half of the viewfinder, the vertical forms of the scene are given more space to penetrate. In giving greater emphasis to the featureless background and the bland surrounding sky, the white overcast backdrop also appears quite oppressive in this misty winter image from an out-of-season promenade.

The distance between you and your subject is fundamental to the design of an image. We've already seen how the edge of the frame can be used creatively to tease the viewer and give an audacious and innovative treatment to even the most mundane subject. The communicative power of an image can change dramatically with the slightest adjustment to position, distance or angle.

Positional decisions have the power to manipulate our feelings at a deeply unconscious level. For example, a politician photographed from above may appear diminished or belittled, their stature literally and metaphorically reduced in size, making them appear vulnerable or childlike. The same politician photographed from a position below eye level may appear statuesque and important, as though we are looking up to them.

Your viewpoint must be adapted in order to contain all the significant information you need for the image. This may require you to go in close in order to give your subject a bold treatment full of impact and authority, or it may require you to pull away, thereby allowing other detail and information to be included within the frame to intrigue the viewer.

Many of the greatest photographers arrive at a scene and without thinking, quickly and quietly 'size up' the situation from many viewpoints intuitively. This approach is the result of a honed and internalised way of working gained through personal vision and experience. Where you choose to capture your image from must be driven by the willingness to create a forceful and absorbing composition, rather than any attempt to simply apply an artful style over a subject that needs a bit of 'spicing up'.

The communicative power of an image can change dramatically with the slightest adjustment to position, distance or angle.

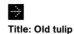

Title: Old tulip

Source/Photographer:
Jeremy Webb

Adopting a suitable distance and placing your subject against a plain background allows your images to be free of distracting backgrounds and unintended clutter.

Distance to subject

The *perceived* distance between you and your subject is usually determined by two key factors: the physical distance between the photographer and the subject, and the lens on the camera.

Telephoto lenses can take you closer to a subject without the need to physically walk up to it. However, they can also distort the spatial relationships between objects – for instance, they make figures in a landscape appear closer together than they really are.

The viewer's emotional engagement with an image can be increased by simply getting closer to the subject, and then framing the subject in such a way that it is emphasised and strengthened by its isolation against a plain background, or given a sympathetic position within the frame. Crucially, the distance you adopt must contain enough significant information within the frame to accurately communicate your intent and exclude anything superfluous or detracting from the principal purpose behind the construction of the image.

Title: The pioneer trumpeter, 1930

Source/Photographer:
Aleksandr Mikhajlovich
Rodchenko

This is an iconic image which for many Americans heralded the beginning of a new era in pictorial modernism. It is one of the earliest examples of a more radical approach to photography exemplified by a brave and unconventional image.

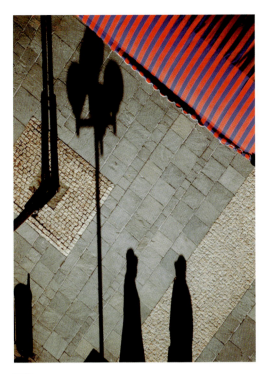

Title: Zurigo, 1981

Source/Photographer:
Franco Fontana

Adopting unusual shooting positions
can bring astounding results. In
this superb street image by Franco
Fontana, the low sun has created
long shadows that provide clues to a
simple situation. The composition is
further enhanced by the skilful use of
diagonals, creating triangular shapes
within the predominantly vertical
structure of the image.

Angle of view

Faced with a subject you'd like to frame
in an interesting way, do you simply
photograph your subject front-on? Or do you
move to the side or underneath to produce
a more dynamic view? Many portraits
appear quite static if the photographer
and subject simply face each other in
the style of a typical passport image.

By adopting an angle of view that sidesteps
the obvious, you can apply a fresh approach
to your subject, be it architecture, landscape,
portrait, fashion or the everyday. Your decision
to use a bold or unconventional angle of
view should be based purely on whether
your approach reveals your subject in a fresh
or revealing light rather than attempting to
mask a poor shot by using an unusual view.

Vantage point and viewpoint

By examining your subject from many
angles and distances, you can decide
the best position to shoot from. In many
cases, the simple act of slowing down
your observation (if time allows) will enable
you to find a position that will show your
subject in an unfamiliar or unorthodox
way. This may require a view taken from
an unusual height, or from below – where
the ground or the sky may offer a plain
background against your subject.

The images here are from a series of shots taken to document public statues and monuments in urban areas. The sculpture, *Monument to Daedalus* by Jonathan Clarke, was a fascinating subject in many ways as it contains a variety of references to both science fiction and classical mythology.

When one moved around the sculpture, its forms made sense in a rounded three-dimensional way, but if you stopped at any particular point its power and impact were somehow reduced. The camera also appeared to flatten the whole subject – the sculpture was situated against a series of winter trees that provided a background of bare branches to create a completely unsuitable background. The light and surroundings also made it difficult to select a lens aperture or telephoto lens to provide a narrow depth of field that allowed the trees to become defocused to the degree required.

The top image shows one of a series taken of the sculpture against a brightly lit winter backdrop. At this distance and position, the essential form of the piece is not shown at its best angle, nor is it easy to separate from the background.

The bottom image, however, shows a shot taken from a slightly lower angle from the other side. This view places the sculpture against a plain sky, which acts as a much cleaner backdrop to the piece. The image was treated to a subtle Photoshop duotone tint to emphasize the form and texture of the piece without the requirement for colour.

Case study 1 Points of view

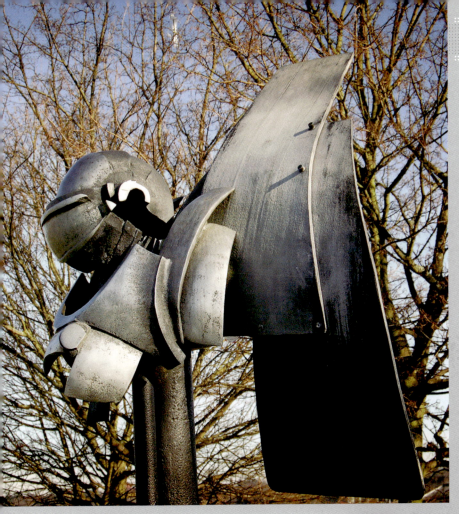

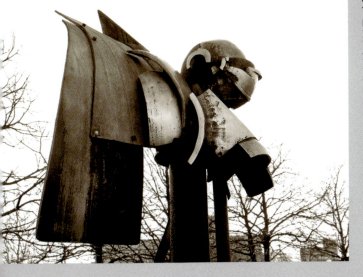

Title: *Monument to Daedalus,* by Jonathan Clarke

Source/Photographer: Jeremy Webb

Height, distance and position could all conspire to offer an unsuitable image background. However, these elements could also be used to give greater emphasis to your subject.

It's often considered that rules, such as they are, should only be broken once they've been learned. Photography is an art form full of rules, most of which we tend to pick up when we are young in order to prevent us from going wrong. As we get older, compositional rules are received and absorbed almost without question. But these rules often inhibit our creativity rather than allow us to strike out with confidence and a fresh perspective. So many rules end up in tedium and predictability.

Why not abandon all rules? Most likely because we'll end up with a kind of shapeless, routeless art that rules were meant to counteract in the first place. Anyone hoping to read anything on design principles in order to become a master photographer will be disappointed – you can't just endlessly replicate what so-called best practice is and end up The Master by slavishly following every bit of advice and regurgitating it. The advice provided in this book is simply a summary of known and trusted wisdom, and hopefully a useful guide too, but it takes judgement and insight to understand when and where these various design techniques are best applied.

Composition and design skills – learned or intuitive?

It's that old nature vs nurture debate: how much of your visual design style is integral to your personality and how much can you acquire above and beyond what you were born with?

Most can be acquired, although it takes time to develop style, which often stems from photography with a clear sense of design at its heart. Many photographers take decades to get into their stride and the work they are often best known for can be vastly different from that which they set out with. This doesn't mean that what they learned in their formative years was wasted – far from it. Moving through different styles and artistic approaches within your photography is not a sign of weakness but of strength – the courage to explore and to keep your vision fresh and curious.

Learning how to apply design skills, or at least working with a greater mindfulness towards design, takes dedication and a willingness to explore creatively. Although no precise formula for 'good composition' can ever be given, at least we can look at all the key components and see how they might work for us when we next put the camera up to our eye.

Moving through different styles and artistic approaches within your photography is not a sign of weakness but of strength.

Title: Untitled

Source/Photographer:
Marie Pejouan

This image is a celebration of colour that skilfully combines strong reds and blues which contrast sympathetically with each other within the overall design.

Most photographers (including photographic masters) have always viewed cropping as a continuation of the process of photography – a chance to fine-tune images at a later stage. The act of cropping exercises the design muscles further and allows the photographer to continue working on an image in order to present their vision in the best possible light. While many purists believe that any 'tampering' with an image should be minimal or non-existent, most pragmatic photographers regard cropping decisions as just another tool in the box.

Adopting a 'no cropping' approach to your photography can be very rewarding indeed. This approach means that prints can only be made from the image at full frame. Working in this way can help to develop vision and strengthen photographic awareness. However, it can also become self-defeating and counterproductive to stick so rigidly to such a purist methodology.

No photographer should be without a pair of L-shaped croppers. Using a scalpel or craft knife and a piece of stiff white A3 card (11.69 x 16.54 inches), make a pair of L shapes like the ones shown. Make sure you have good, clean edges and that your internal corners all have right angles of 90 degrees.

Using your croppers, try to find alternative compositions to some of your best prints. By experimenting with a series of extreme or minimal formats and going in closer, can you create alternative meanings or more absorbing compositions? Can you add more impact by simply adjusting this new viewfinder frame and improve on the originals? Can your cropping bring design lines or shapes into play that strengthen or diminish elements within your image? If necessary, make notes on your findings or sketches of these new compositions for future reference.

Exercise 1
Cropping

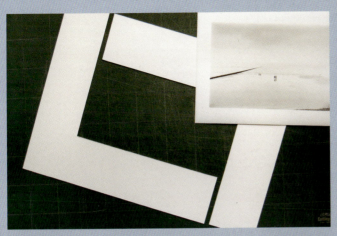

Title: Croppers

**Source/Photographer:
Jeremy Webb**

Adjusting the frame proportions and size can dramatically alter the compositional appeal of an image. If you've never had the opportunity to experiment with different camera formats, here's your chance to discover how altering the very edges of the frame can reposition the image elements and powerfully affect the image as a whole.

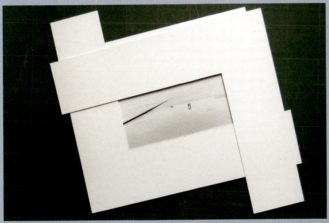

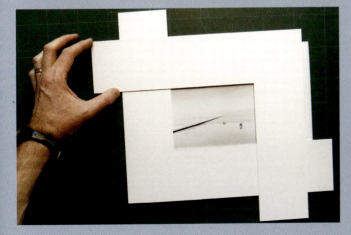

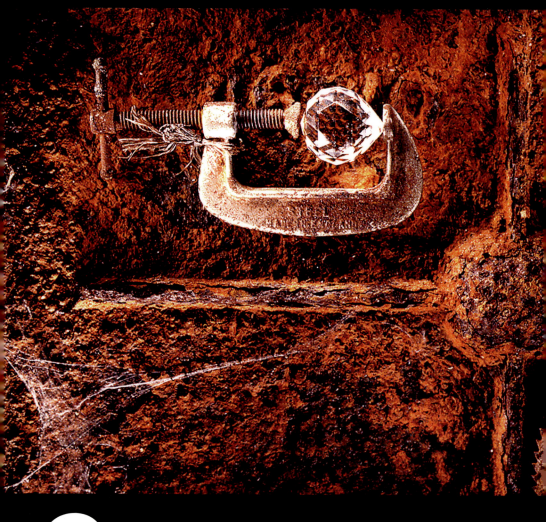

2

The elements
of design

Title: Gemstone in clamp

Source/Photographer:
Jeremy Webb

Torch-lit still life presents many challenges, especially where subjects of varying light reflectance exist within the same image. This still life combines various shapes and textures positioned harmoniously within the frame while the light was 'painted' around the scene during an exposure of 40 seconds.

From the earliest scratchings on cave walls to our current image-saturated world, a multitude of artists, theorists and art historians have all immersed themselves enthusiastically within an analysis of the visual arts (painting and photography in particular) in an attempt to establish a general set of principles—the so-called 'elements of design'. These elements or 'raw ingredients' determine the compositional appeal of an image— how easily it can be read by an audience, how positively the audience responds, and how much value an audience places upon the image viewed.

Composition is first and foremost the result of a dynamic design process that the photographer undergoes during the act of image capture. This process naturally extends to include the act of cropping, contrast changes, saturation adjustments, or any number of post-capture techniques that arise from the photographer's quest to create the best possible composition for an image.

Design elements can be skilfully incorporated to an image as a kind of invisible blueprint in order to create a structure that supports compositional appeal or power. Design principles exist at every stage of the image creation process – from the moment a photographer adopts a position to shoot from, to the placement of the subject on the printed page, up to the positioning of an image at an exhibition.

In the visual arts, the use of line is perhaps the single most important element of design. It denotes boundaries and can be actual or virtual. It can be real and apparent, or an invisible structure that guides our gaze between points on canvas or print.

The use of line can significantly affect the compositional success of photographers' images. Lines are powerful design elements that re-enforce the three-dimensionality of the world. It's a deeply primeval impulse – as children, our first scribblings on paper are lines; so were the first cave markings recorded by humankind. Lines are always used in artistic terms as the primary tool to represent our understanding of the world.

Vertical lines

Vertical lines can provide notions of strength and certainty within an image. Towers, trees, even our age-old ideas of spirituality and religion, can all be reflected by vertical lines – actual or virtual. Vertical lines that shoot upwards have always held a symbolic relationship between heaven and earth – between the Gods and mere mortals.

Horizontal lines

Horizontal lines often reflect concepts such as stability, continuity and restfulness. Think of table tops or the horizon line over the sea. Within the rectangular format of a traditional photograph, horizontal lines lie parallel with the top and bottom edges where they promote a feeling of harmony and unity within the image.

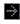

Title: Posts, Burnham Overy

Source/Photographer:
Jeremy Webb

Vertical lines set within a horizontal frame can add interest by imparting an upward movement that is at odds with the sideways structure of the landscape format.

Title: Dog walking, Gorleston-on-Sea

Source/Photographer:
Jeremy Webb

Against the single line of the horizon, figures are picked out against the foamy shoreline in an image that emphasizes the empty space of the Norfolk coastline.

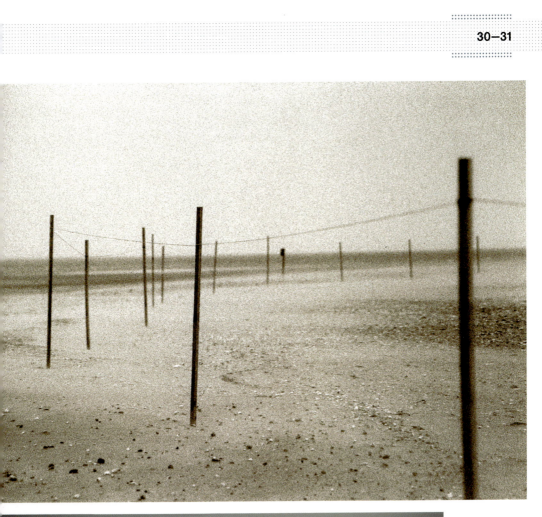

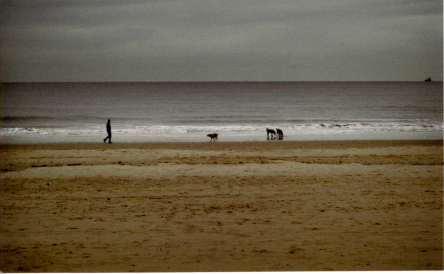

Diagonal lines

Diagonal lines disrupt the certainty and simplicity of horizontal and vertical lines. They almost always impart a more energetic and active feeling when set against the passive north–south journey of the vertical or the west–east route of the horizontal. In the three-dimensional world, diagonal lines represent motion and action. A leg that is vertical is stationary, but a leg that is diagonal is a leg in motion – one that is walking or running.

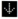

Title: The ENRON building, Houston, Texas

Source/Photographer:
Damien Gillie

The architectural density of many of our large city centres provide opportunities to create dynamic images infused with design. Damien Gillie's image shows an interesting convergence of diagonal lines and forms full of contrast and colour, cut off by a dense triangular form entering the scene from the opposite side of the frame.

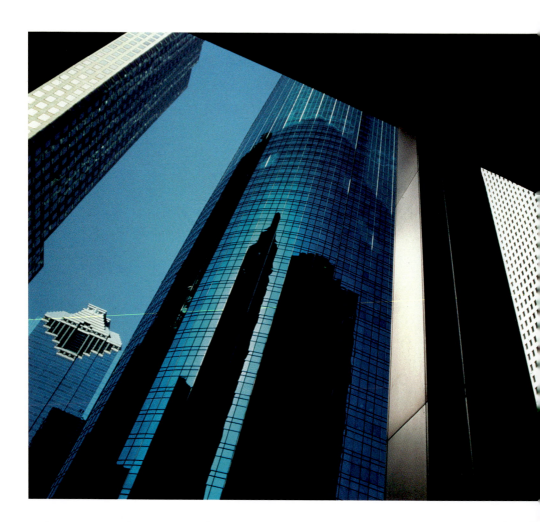

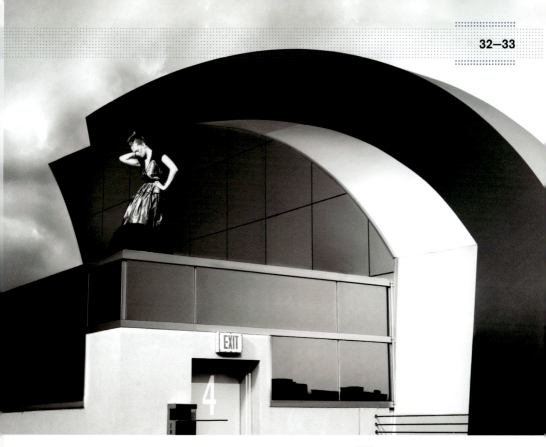

Curves and arcs

A curved line often adds a softer dynamic to an image. Compared to the rigid straight lines of the viewfinder or print edges, a curved line can indicate something soft or subtle. Many curves or arcs are found in nature and the folds and multiple forms in the human body.

Title: Curves

Source/Photographer:
Alberto Oviedo

The use of architecture as a backdrop to fashion is a powerful combination that relies on the use of bold shape and form to accentuate or emphasize the model's pose. The curved sweep of the building's roof in this image counteracts the otherwise right-angled nature of the background and provides a strong shape that draws in the eye towards the standing figure.

A curved line can indicate something soft or subtle.

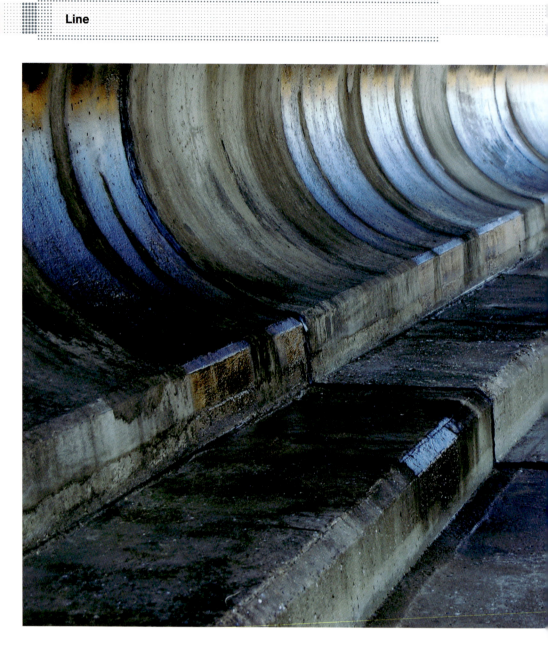

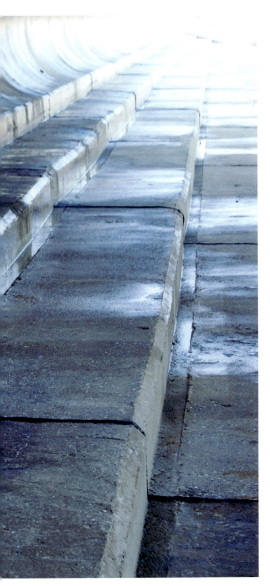

Intersecting lines

When one line crosses another, the lines are said to intersect each other – they pass through or cross over each other's path. Photographers can place subjects at the points of intersection to maximize subject impact and emphasis.

Converging lines

Lines that meet at a point in the far distance are said to converge. Stand on a railway line and look into the distance – you will see both sides of the track appearing to merge into one. In photography, converging lines can represent distance, scale, height and power. If a subject is placed at the point where lines converge, powerful compositions can be made.

Title: Dune protection, Winterton-on-Sea

Source/Photographer:
Jeremy Webb

Converging lines often meet at a point outside the frame. By deliberately framing your image in such a way, converging lines often emphasize depth and distance as they travel through the image.

Shape or form is often the end result of boundaries created by lines. In photography, three-dimensionality is reduced to two-dimensionality and so the use of design awareness to maximize interest in the shape or form represented is critical.

For this reason, photographers will often talk of images being 'flat' where a subject may be rendered without much emphasis on its form or the space it occupies. This may be the result of poor lighting or poor positioning, or it may simply be that the scene itself is too cluttered to allow a single subject to be isolated and focused on.

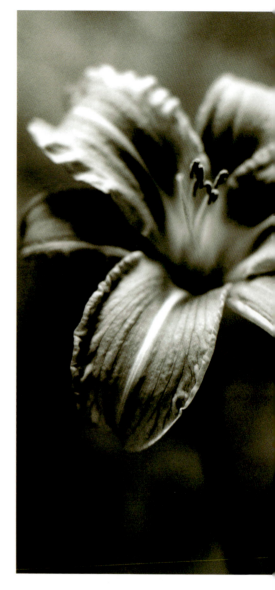

Title: Lily

Source/Photographer:
Jeremy Webb

Simple shapes and forms often require controlled lighting to bring out the most interesting aspect. This single lily was bathed in soft daylight from above and slightly behind to make the most of its soft appearance.

Created or revealed by space

The use of shape is often applied with the greatest effect when a distinctive form or outline is set against a plain background, thereby minimizing any distractions and allowing the viewer to focus squarely on the shape presented. In design terms, this is often referred to as good foreground/background separation. This is why silhouettes are so universally understood – they present a strong and recognizable shape that is contrasted easily against a light background.

Title: Red tulips, Japan, 1980

Source/Photographer:
Ernst Haas

Unusually, for many photographers of Haas's era, the black background to this image was used quite deliberately to give strength and richness to the red colour of the tulips. The effective use of lighting reveals the droplets, and the positioning of the flower heads also gives this image an unusual, but very forceful composition.

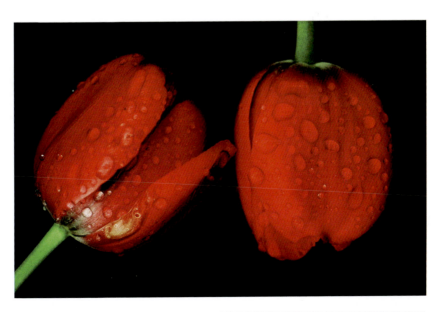

Lighting

Photographers who are successful in allowing their subjects to appear 'solid' are photographers who have a keen eye for the properties of light. In the hands of a skilled photographer, the lighting allows subjects to be rendered in high or low contrast; shadows can help to define the subject, or reveal the subject's positioning within the wider scene.

Title: Yurt kitchen

Source/Photographer:
Libby Double-King

Photographs allow us to embrace and interpret the effect of light on our subjects. This simple 'found' still life shows the effect of a small and diffused overhead light that seems to bathe the curve of the wooden shelf in a soft light; it allows our curiosity to explore darker areas as the light recedes into the background.

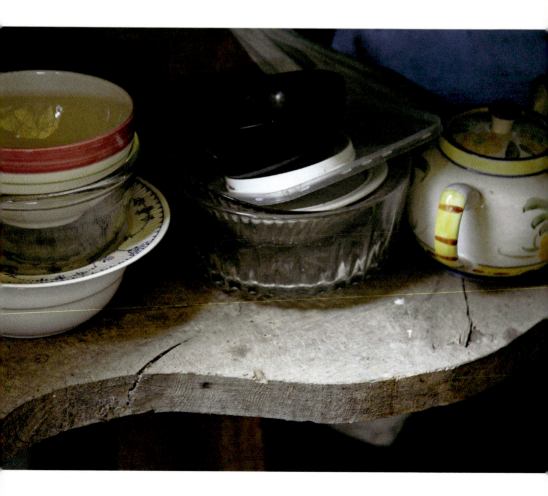

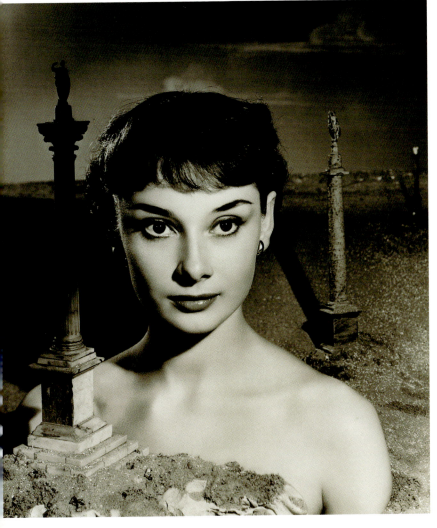

Title: Audrey Hepburn, 1950

Source/Photographer:
Angus McBean

The above image is one of many famous portraits by Angus McBean. The surreal nature of this image is further heightened by the appearance of a strong shadow from the column in the background. It appears to signify strong light from a completely different point to that which lights the actress herself.

Objects

The photographer who carefully considers the shape or form of the subject will seek to give great emphasis to it. There are many design elements to consider and experiment with – lighting, positioning, vantage point, and distance, for example. However, the complexity and character of the object itself is critical to how you generate interest and engage with your viewer.

Title: Pods of chance

Source/Photographer:
Olivia Parker

Natural subjects offer a huge variety of strong shape and form to play with. Olivia Parker uses soft lighting and an eye for simplicity to create this wonderful image.

Title: Early morning boudoir table

Source/Photographer:
Smart Photography Ltd

Bright sun or studio lighting picks up the highlights and reflections in this colourful advertising image rich in warm reds and oranges. The direction of the light allows the glass to reveal its contours and shape in a way that flat soft lighting would be hard-pushed to achieve.

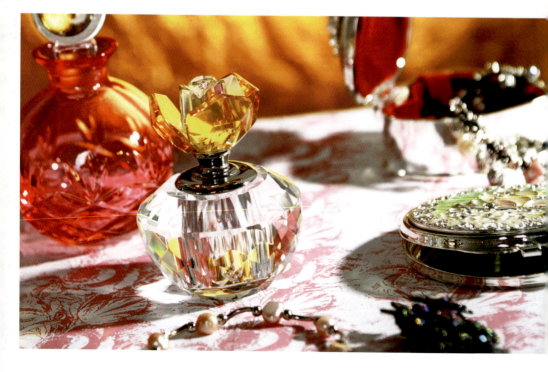

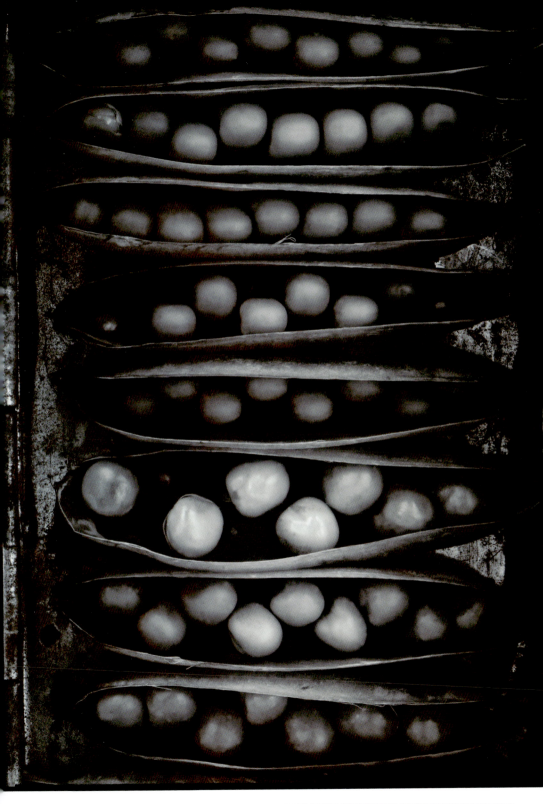

Space is often the last aspect considered when composing an image, but it deserves the attention of a creative photographer. We grow up conditioned to fill space when what we often need to do is take something away in order for the entire image to have more power and impact.

In photographic terms, space can either be the two-dimensional space on a print or flat image, or it can mean three-dimensional space – the real or actual space present at the scene.

Space can reveal a subject forcefully; it can create the impression of depth within an image. Manipulating space allows the photographer to overcome the challenge of placing a fragment of the three-dimensional world on a two-dimensional piece of paper.

Negative and positive

Negative space is the absence of volume or mass. It's what lies behind the subject and often takes on a passive role in the image. Positive space plays a more active role within the image – there's a sense that the photographer consciously manipulated the space to emphasize the subject or that the use of space compositionally has had a positive effect on the subject.

Foreground/background relationship

When the subject and background are too similar, the viewer's ability to 'read' the image is hindered. This often happens when the photographer tries to show too much, or frames the scene poorly.

As a result, the viewer's attention will wander and, without a clear point of interest, any further involvement with the image will be lost. The foreground/background relationship can be strengthened by increasing the contrast or difference between the two elements.

Space can reveal a subject forcefully; it can create the impression of depth within an image.

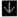

Title: Motel telephone

Source/Photographer:
Bryan Schutmaat

The symmetry of this image is disturbed by a single element – the wire that climbs up the wall from the bed on the left.

Title: Fist impression

Source/Photographer:
Jeremy Webb

Confusion between negative and positive space can easily deceive our eyes. Is the fist impression on the florist's block extending towards us? Or is it receding away from us?

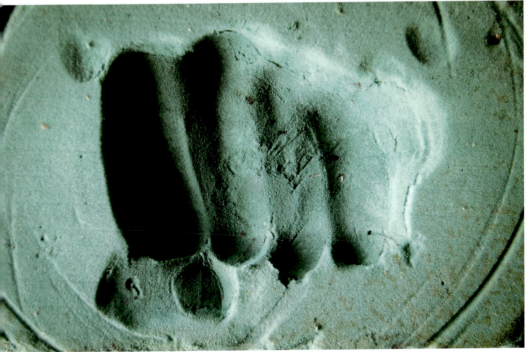

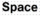

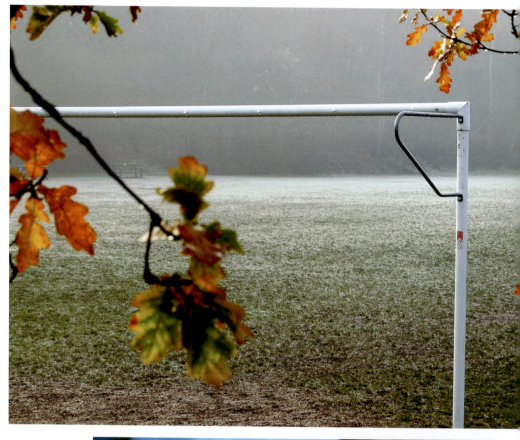

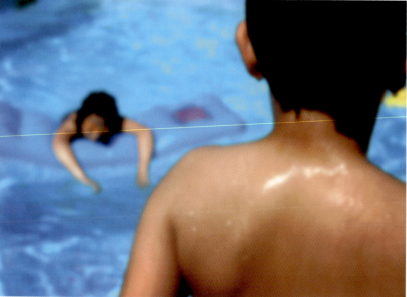

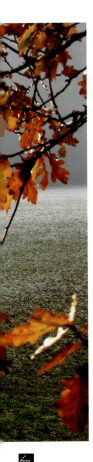

Title: Soccer pitch, Mousehold Heath

Source/Photographer: Jeremy Webb

The flatness of any image has to be seen through in order that the spatial relationships between different areas can be untangled and made sense of. The distances between different areas of an image are often confused by the focal lengths of lenses, where telephoto lenses, for example, make subjects appear closer than they really are.

Title: Adday floating

Source/Photographer: Jeremy Webb

Deliberately shooting out of focus only really achieves its effect when applied to a simple subject such as this. Too much detail or too little foreground/background separation will overpower the simple forms necessary for this type of approach.

Spatial relationships

Spatial relationships denote the distance and positional relationship between one subject and another within an image. If the distance between subjects is confusing or unclear, this can be said to be an ambiguous spatial relationship. For example, the subjects may be closer to (or farther apart from) each other than we think. Photographers who can shoot their images from unorthodox positions where ambiguous spatial relationships occur can create some very absorbing images that force the viewer to work a little bit harder to determine a sense of the spatial relationships on offer in an image.

Creating depth or confusing the eye

Creative photographers are often finely tuned to the power of space and can play with the concept of space to achieve illusions of depth and distance within their photography. This can be achieved with careful positioning (for example, allowing similar subjects to blend into each other thereby obliterating their outlines or edges) and effective use of equipment. Lenses show wide variations of depth depending on their focal length.

Wide-angle lenses, for example, take in a wide area and can adequately show both near and distant subjects clearly in focus. As such, they can exaggerate the distance between near and far, often giving the impression of greater depth. Telephoto lenses, on the other hand, tend to compress a scene and subjects that are far apart appear to be closer together than they really are.

Photography manages to combine the dual power of texture with light in many extraordinary ways. Without light, texture could not be seen, only felt. The synergistic effect of light on texture has the strength to affect us deeply through the photographic medium.

Many of us marvel at photography's ability to show detail – some images present surfaces and textures that make us want to reach out and touch them. Such is the astonishing power of texture.

Rough

Rough surfaces such as gnarled wood or coarse fibre material can often be best revealed by strong directional lighting rather than flat, soft lighting such as that produced by an overcast sky.

Strong sidelight, for example, easily picks out the detail and contours of a craggy face or a dune-filled landscape that contains a multitude of dips and peaks. These variations in surface texture, when illuminated by a low raking light, for example, will trap light or let light escape thereby producing stronger contrasts of highlight and shade. This in turn results in an image with a strong pattern.

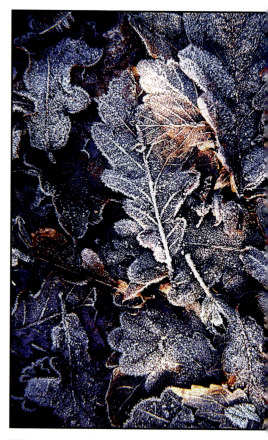

Title: Frosty leaves

Source/Photographer:
Jeremy Webb

Low winter sun helped to pick out the frosty texture of this scene. The blue colour is typical of the shadows cast at this time of year and helps to accentuate the chilly winter feel.

Some images present surfaces and textures that make us want to reach out and touch them.

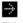

Title: Skin

Source/Photographer:
Jeremy Webb

Rough textures often require low
lighting in order to accentuate the
folds, creases and dips of a surface.

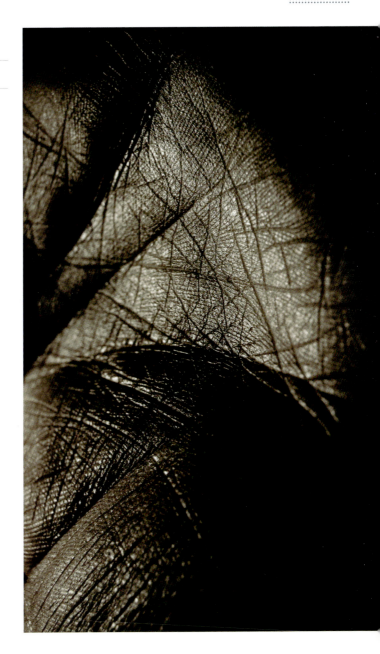

Smooth

Many smooth textures, such as polished glass or metal, may be said to have no texture at all and yet we know from the photographic evidence in front of us what they would feel like due to the combination of light falling upon the subject and other elements within in image. Smooth surfaces often impart a sense of calm or relaxation.

Random

Different textures appearing in one subject or image can present problems to the photographer. While one type of surface may suit one type of lighting, other textures may require something else altogether.

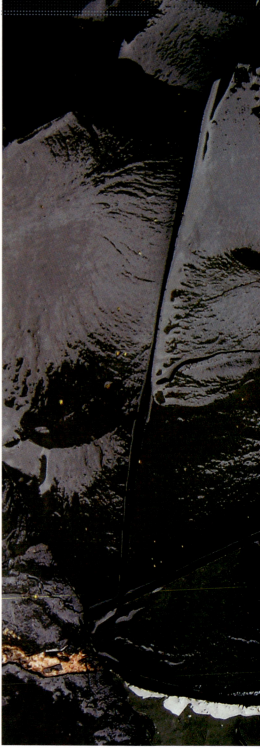

Title: Wet rocks, Auchencairn

Source/Photographer:
Jeremy Webb

The slippery smooth surface of wet rocks is only visible if the light, viewpoint and framing are used together effectively to emphasize its surface appearance.

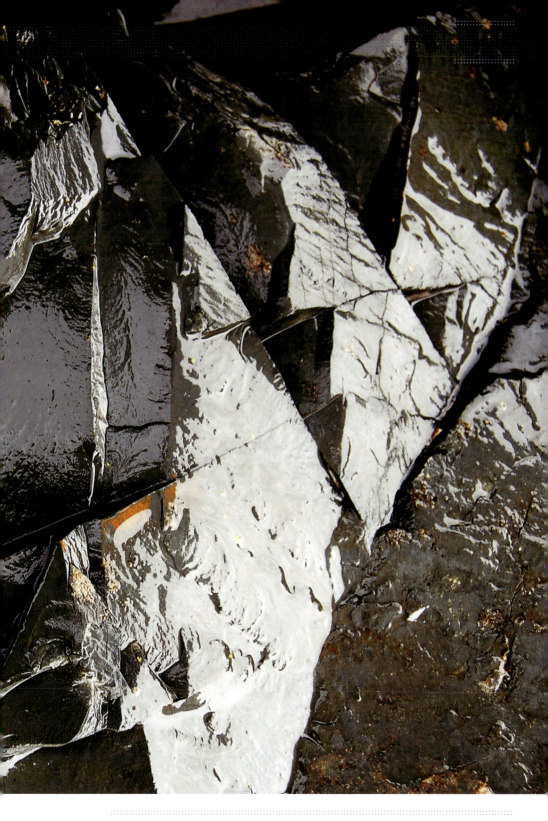

Light transforms everything it touches. The images here were both taken at the same location, from virtually the same vantage point, but at very different times of day.

The bottom image shows the smash of a wave against the side of a jetty. A fast shutter speed has frozen most of the movement, but allowed some motion to show in the water in order to increase the drama of the scene. It's a reasonably successful image in that it conveys a clear intention and communicates a sense of the power of the sea.

The top image was taken at the same location approximately six hours later. Here, the sea is less dramatic, but the low winter sun – about to disappear below the horizon – has picked out the wave and cast it in a golden light at its moment of impact against the jetty wall, creating a more exciting and appealing image.

For most photographers, light and time are not simply 'x' and 'y' in some precise equation expressing how long the shutter remains open, or how long a print should be exposed for in the darkroom. Time is inextricably linked with light in a much more fundamental way. It allows us to observe the changing nature of light over the course of many hours and enables us to control the moment of capture.

Title: Gorleston-on-Sea

Source/Photographer:
Jeremy Webb

Landscape photographers will wait for hours for the light to be right. If you can afford the time to set-up your shot in the right light, the rewards are well worth it.

Case study 2
Light and time

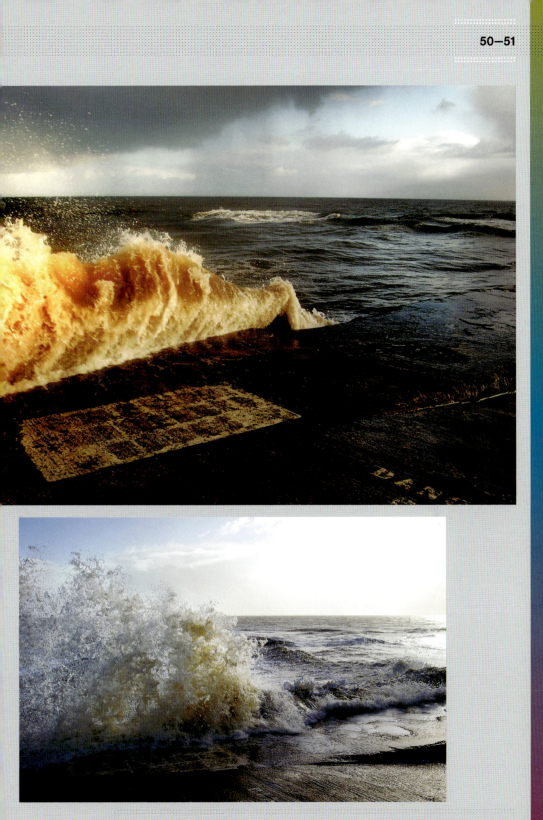

Light is the fundamental currency of photography – light is what makes it all happen. Without it there is no image. Light transforms everything it touches and photographers have their own vast language to describe its many forms.

Look at the world's greatest photographs, from Edward Weston's *Peppers* to a Rankin portrait, and the photographer's respect, understanding, and control of light is probably of equal value (if not more) to the subject itself. How we see light, how we understand its properties, and how we control and manipulate it, is what sets great photographers apart from the journeymen. To many photographers, there is simply no such thing as bad light, just 'challenging lighting conditions'. Some photographers thrive in low-light situations where tripods and slow shutter speeds allow the process of photography to pause the world for a brief moment – enabling us to capture the motion of water or to freeze the speed of a hummingbird's wings.

Quality

The quality of light usually relates to the source, direction and amount of light in a photographic image. Mood and emotion are heavily influenced by the quality of light applied.

Large, broad sources of light will deliver soft lighting to a scene or subject, much like the overcast sky on a landscape. Small, narrowly focused light, such as that produced by a flashgun or the bright sun, tends to produce harsh light that gives hard shadows, which provide greater contrast.

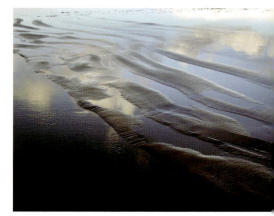

Title: Sky reflection

Source/Photographer: Jeremy Webb

The light from a winter sky shows the smooth surface of the shallow water and the texture of the sand.

Title: Windowlit figure

Source/Photographer: Jeremy Webb

Soft daylight is perfect light for figurative work in photography.

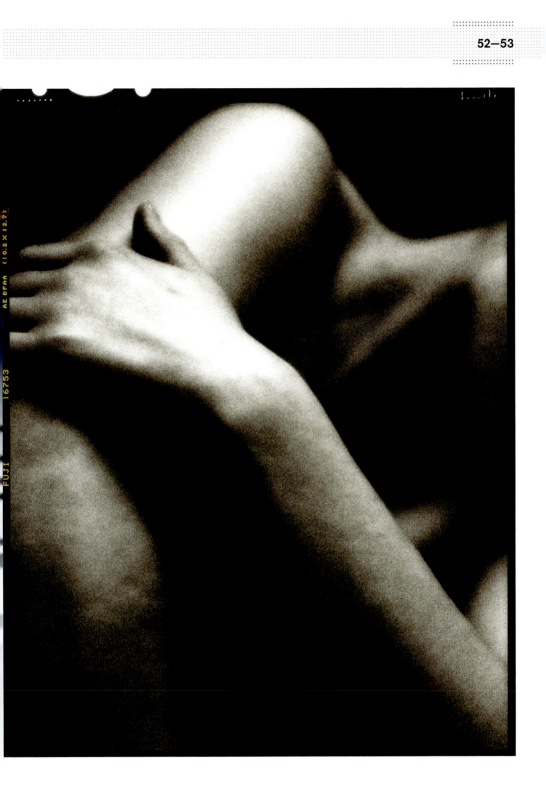

Direction

Photographs often provide useful clues that lead us to understand some component of their construction. This in turn often leads to an understanding of a photographer's intent or motivation.

Shadows are an obvious example of this since they imply both the quality and the direction of the light the subject is cast in. Light can come from above the subject, from the side, or from below the subject.

Again, the direction of light can have dramatic effects on the emotional reading of an image. Heroic figures in action-movie posters, for example, are often shot in bright overhead lighting that emphasizes the masculine features of a face or a sculpted torso. A horror villain or vampire, on the other hand, will often be lit from underneath in order to maximize the sense of threat or evil.

And for anyone who doesn't believe that these lighting effects are more fantasy than reality, look up the portrait of Alfred Krupp by Arnold Newman and find out how this image led to real ramifications for both photographer and subject.

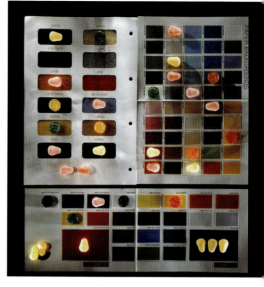

Title: Sweets on swatches

Source/Photographer:
Jeremy Webb

The lighting for this image was provided by a single small torch. By using a long time exposure, the image records the shadows created by a multitude of different angles as the light was 'painted' around the scene.

Title: Asian girl

Source/Photographer:
Barry McCall

The drama of this image is heightened by a lack of light from the front (photographer side) of the model, and increased further by the use of backlighting and sidelighting, which emphasizes the sculptural nature of the pose.

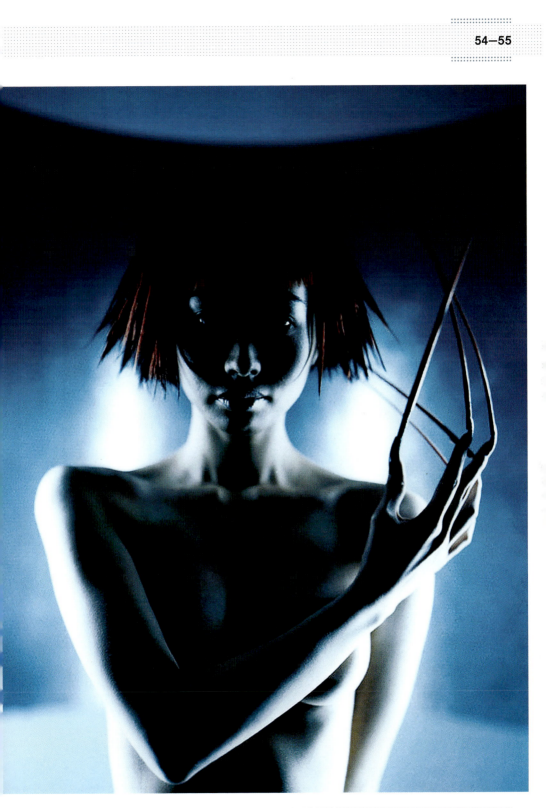

Strength

The strength of light is often called 'intensity'. Bright light has many benefits for the photographer. It may create shadows that can be useful for composition and it can also give a sense of depth to the image. Strong light may require fast shutter speeds that can allow action to be temporarily 'frozen' and studied. It may also require the use of a small lens aperture, which would provide good depth of field, thereby allowing the photographer to achieve good focus and sharpness throughout the image.

However, strong bright light can have negative effects as well. All of the benefits above can also be drawbacks or limitations if different creative approaches are required. It may be that the shadows generated destroy the detail of something present within the scene, or that a wide aperture is required as the photographer intends to apply a small depth of field in order to emphasize only a certain aspect of the scene.

There are, of course, many technical solutions to these problems, but photographers must not assume that bright light equals good and low light equals bad. There simply exists a range of different lighting intensities, all of which provide opportunities and challenges to the creative photographer.

How light reveals hidden pattern

Different subjects demand different treatments from photographers. Beauty portraits, for example, require broad, bright and soft sources of light that soften and conceal wrinkles and the natural texture of human skin.

On the other hand, the craggy features of an old person's face, for example, may require the photographer to reveal the rich pattern of random creases in stark contrast, exposing the crevices of the skin's surface by using directional side lighting to emphasize the texture.

Photographers must not assume that bright light = good and low light = bad.

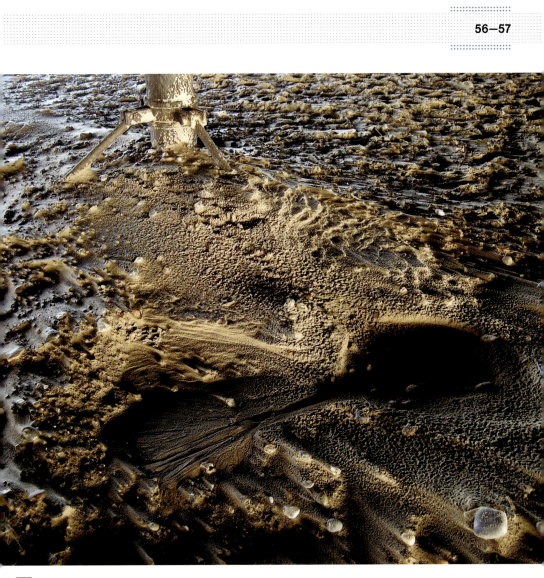

**Title: Under the pier,
Great Yarmouth**

Source/Photographer:
Jeremy Webb

Winter sunlight rakes across the
surface of the sand under a seaside
pier, revealing a textural pattern
created by the wind-blown sand.

Texture

As we've already seen, texture is simply 'touch sensation' without the illuminating properties of light. Texture can be felt, described in words or understood spatially. Without light, however, it remains in darkness like the rest of the material world.

Photographers who understand light, and who know how to control and manipulate light, will expose texture in a multitude of innovative ways to make it as powerful as possible within the limitations of the two-dimensional image. There isn't another medium that can act so powerfully on our perception of touch. Photographers who are fluent with their technique and who are sensitive to their subjects learn how to capitalize on textures through careful use of lighting, positioning and viewpoint.

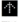

Title: Hemsby sand, Norfolk

Source/Photographer:
Jeremy Webb

The texture of sand is revealed by hazy overhead light as it picks out the ridges and contours of the dune.

Title: Provence, 1976

Source/Photographer:
Martine Franck

The shadow created by the boy in the hammock is essential to the compositional strength of this bold image. In your mind's eye, try removing the shadow and see if the image remains as strong without it.

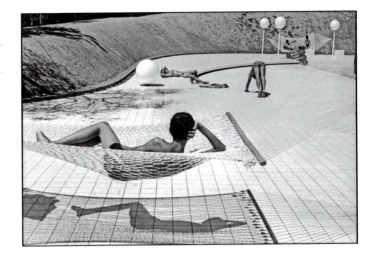

Light creating long shadows

Shadows are as important as light. You simply cannot have one without the other. They are fundamental to our emotional connection to an image and affect our subconscious at a deep level. As children, we may invent danger lurking in the unseen, or enjoy the ability to hide ourselves from view within a shadow. Under controlled situations you can, of course, choose a lighting style that minimizes shadows, or makes the most of their dramatic presence.

Hard, solid shadows are the result of a single, strong, directional source of light such as the sun or a flashgun. Soft shadows arise from softer, broader sources of light such as light reflected from a ceiling or an overcast sky.

Long shadows are created by low-angle lighting, and their visual strength can be emphasized by simply making these dark shapes integral to the overall composition of the image.

However, we don't simply have to accept what nature (or expensive studio lights) throw at our subjects. We can control the strength of shadows by reflecting light back into shadow areas, thereby softening the contrast between highlight and deep shadow, if that is the effect we require.

Understood and celebrated by every culture and every stage of human development, our sense of colour is a primary visual force in our lives; it is of critical importance to photographers. Colour affects our moods and perceptions – it has a direct and measurable impact on our heartbeats, body temperatures and metabolisms. For the photographer, colour provides a massive avenue for experimentation; immersing one's self in its potential for photography is wildly fun and thrilling, yet also complex and unnerving when one realizes its power to affect our perceptions of the world.

Colour psychology

There are many well-known and scientifically proven connections between our experience of colour and the resulting states of mind that they induce. Photographers with a keen sense of this power can access the palette of the rainbow to powerful effect. In the simplest terms, blues and cyans can induce a sense of cool, while warm reds and oranges impart a feeling of warmth. But the power of colour goes far deeper than this.

Colour can be used to create contrast in a number of ways. The so-called 'warm' colours appear to move forward and out of the page or print, as if advancing ahead of other colours. On the other hand, cooler blues and greens often give the illusion of holding back – they provide a hint of reluctance to come forward and do not present themselves with confidence in the same way as warm colours do.

Contrast can also be created through the positioning of strong colours against pastels, or the more obvious dark against light. Impact and immediacy are the result of strong, active colours positioned together, while a sense of calm relaxation often results from dark or neutral backgrounds used to promote a single colour subject.

Title: Merry-go-round

Source/Photographer:
Ricki Knights

The deliberate placement of colour opposites evoke an emotional response. In this image the cool blues of the dark sky and the warmer, more inviting reds create an image rich in colour psychology.

Title: Red velvet cake

Source/Photographer:
Mary Amor

This image uses unconventional framing for impact, which makes the most of a single colour at the heart of its construction.

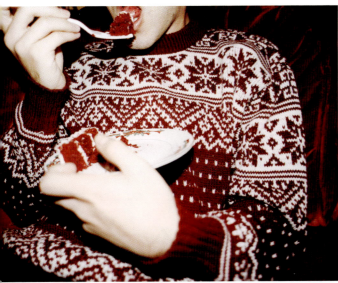

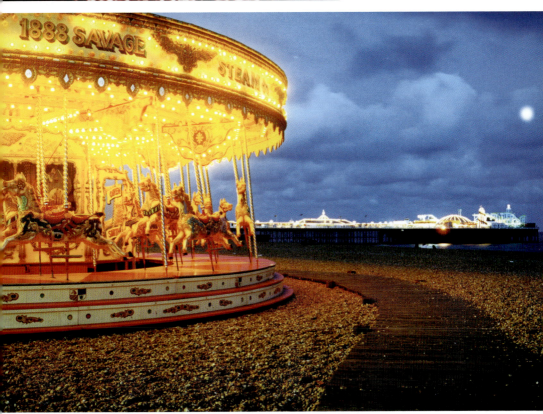

Complementary colours

The most commonly known and recognised complementary colours are red paired with green and blue paired with yellow or orange. However, with photographers now being more adept at manipulating both primary and secondary colours, green and magenta or red and cyan are now used as powerful combinations that provide strong contrast.

These 'dynamic duos' come from opposite areas of the colour wheel and produce powerful effects on the retina. However, their effects can be dulled or lost by introducing further colours or shapes to the composition.

Single colour strength

Sometimes an image comes alive when one colour dominates the scene. For example, a single splash of red amidst an image of greys and muddy browns will immediately grab the attention of the viewer.

More often than not, a primary colour will achieve this result faster than a predominant pastel hue of subtle shade. It's interesting to note that a simple red square will appear to be of a darker hue when placed on a black background, and yet the same identical square will appear to be of a lighter hue when placed against white. This is an extremely simplistic example of the phenomenon by which colours can be manipulated in terms of their perceived hue, depending on the context or background within which they are placed.

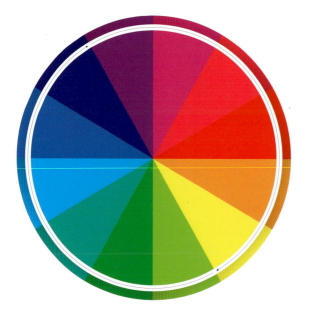

Title: Colour wheel

Source/Photographer: Gavin Ambrose

The colour wheel for photographers is different from the colour wheel for paint and pigment. It shows the primary colours of red, green and blue equally spaced within the wheel. An understanding of the colour wheel is important if photographers are able to correct colour casts, for example, in their digital image editing. Opposite colours are introduced to cancel out a colour cast on the opposite side of the wheel (for example, cyan can be increased in order to reduce a red cast).

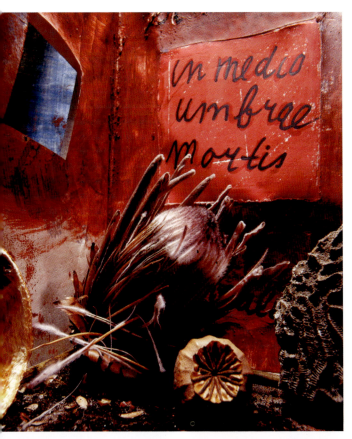

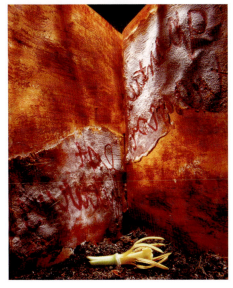

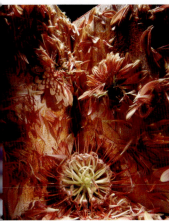

Title: In medio umbrae, thurmoil, broken dreams

Source/Photographer:
Rommert Boonstra

These three images emphasize vivid reds at the core of their construction, but their vibrancy is strengthened further by lighting, texture, strong composition and a powerful appreciation of the visceral.

Bold colour vs subtle colour

The strength of colour can be utilized to affect our mood and level of engagement with an image. Bold and assertive primary colours often announce the intention of an image – to shock or surprise, whereas a palette of soft and subtle colour invites us to form a quieter, more contemplative relationship with an image.

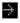

Title: Mushroom on a winter beach

Source/Photographer: Vadim Tolstov

The cold blue shadow created by this structure mimics precisely the same shade of blue found on the structure itself.

Title: Spanish farm

Source/Photographer:
Libby Double-King

Photographers should work with colour in all its forms, from brash and bold to soft and subtle. This beautifully simple image shows how pastel colours can blend harmoniously when used with a strong compositional eye.

Bold and assertive primary colours often announce the intention of an image.

Mono in colour

Occasionally, photography offers us a situation where the subject itself provides little, if any, colour, and appears to be completely monotone. Some examples are silhouettes against a cloudy sky, or patterns revealed by the play of light on water.

Presented within a colour series, such images immediately stand out, appearing as if they don't belong, but also remaining tied by theme or subject to the set. Many photographers enjoy monochrome precisely because it focuses their ability to experiment with design principles in a slightly different way.

Photoshop monochrome conversions

Many photographers who begin to explore Photoshop assume that monochrome conversions can simply and easily be made by desaturating the image of colour. This will result in a bland and tonally incorrect conversion. Use the Channel Mixer instead, with Monochrome checked, then edit each colour channel in turn until the desired effect is achieved.

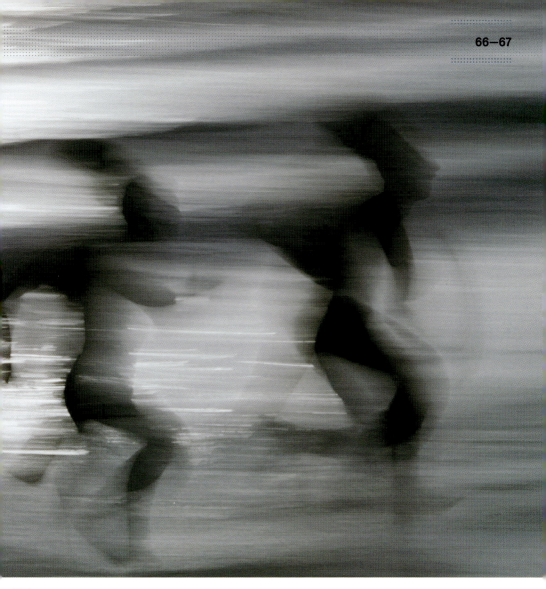

Title: **Beach running**

Source/Photographer:
Ernst Haas

Ernst Haas was well known for his use of slow shutter speeds. Shooting into the light, the photographer has created an image full of movement that requires no colour to succeed.

One of the greatest challenges facing the photographer is the requirement to remain photographically 'fit' in order to develop an awareness of design and its impact on creativity. No concert pianist or ballerina walks onstage without going through endless hours of practice, warm-ups and exercises beforehand in order to reach a pinnacle of readiness and technique. So why do photographers expect to take great pictures all the time without undergoing similarly rigorous workouts?

As photographers, we often experience the blank page of a world full of possibilities, but also the crushing weight of responsibility to make something of it. This exercise addresses that problem by allowing you to take time out to experiment with your design skills and place restrictions on your raw materials. In this task, you're invited to combine and use only a few items in order to come up with some simple designs drawn from your creative approach to the exercise, and your careful choice of lighting and background.

The raw ingredients? An egg, six small twigs, a glass lens, and a length of string. You can use as few or as many of these elements as you like, but use only these items in your compositions. Limitation will force you to use design skills to create minimal or complex designs, explorations of line, tone, contrast, texture and so on. Remember that you also have two very important additional ingredients to work with: light (soft, side, harsh, raking, etc) and background (black, textured, plain, crumpled, etc). Approach this opportunity with an open mind and plenty of time, and you can learn a lot about yourself as a photographer.

Exercise 2 Design limitations

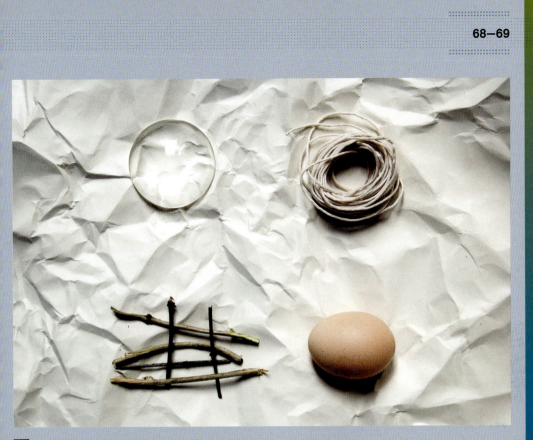

**Title: Raw elements for a
design exercise**

Source/Photographer:
Jeremy Webb

Restrictions placed on a creative
exercise can provide meaningful
boundaries within which to work;
they enable you to design your image
with more creativity and focus.

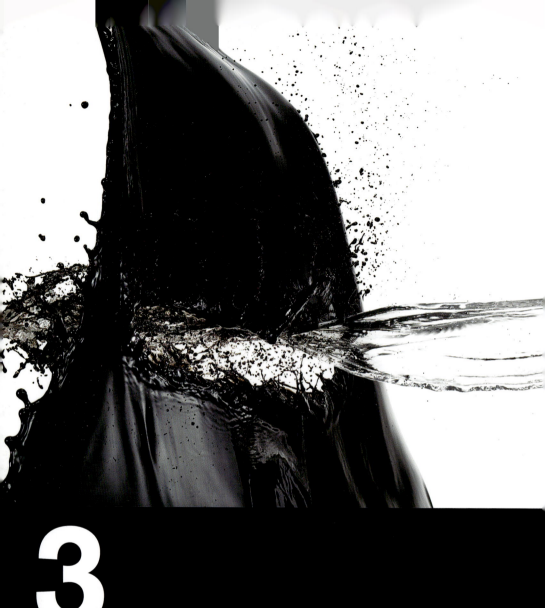

3
First design principles

Now that we have discussed the major elements of design, we now have the opportunity to mix these 'ingredients'. This practice leads photographers down some very exciting paths and images.

The previous chapter looked at how the components of design can be isolated and examined within a compositional approach to photography. This chapter is all about how you can actually apply these components to your work. The principles of design are the processes by which the elements of design come into play within an image.

Beyond an initial gut reaction to the subject of a photograph, it's very often the application of design principles that really make us stay hooked on an image. For some photographers and/or audiences who ask 'What makes a good photograph?', we can confidently assert that a large part of the appeal of a photographic image is the application of design principles; it is the blending, manipulation and combination of different design elements that create compelling imagery.

Title: Kusho 3

Source/Photographer:
Shinichi Maruyama

Liquids, powerful flash and an intuitive sense of timing (developed over many years' experience) have culminated in an explosive collision that freezes the motion mid-air and allows us to study a fraction of frozen time at our leisure.

When any design element (line, shape, negative space, etc) is repeated a number of times, a pattern develops. Patterns exist all around us: in clothing, wallpaper, books, paving stones – everywhere. Many other art forms, such as music or dance, use pattern because the repetition of a shape, word or form is comforting and easily understood. It reinforces our understanding of a single element by having its power amplified; it also imparts an emotional certainty, which can be reassuring.

The appeal of pattern is a universal phenomenon. However, photographers should beware of applying this process too often in their work as it can become an easy retreat into a kind of template imagery; this can impede the employment of additional creativity or compositional invention in the capturing of a scene or subject.

There are a number of patterns that photographers can capture through careful positioning and manipulation of viewpoint and distance. Even then, the skilful photographer may still need to employ further techniques to creatively rise to the challenge.

Patterns exist all around us: in clothing, wallpaper, books, paving stones – everywhere.

Random patterns

This is an odd term to grasp, since the term 'random' itself means it has no specific pattern, purpose or objective. Random patterns are those where a multitude of identical shapes or forms might be present within an image, but their distribution and placement throughout the picture may be uneven and/or unpredictable.

An example of this might be the digital interference on a television screen where a picture breaks down because of poor reception or connection. The picture suddenly becomes abstract and the resulting large digital pixels or squares (the elements) might be unevenly placed in varying groups of size or colour within the frame of the screen.

Title: Key West, 2000 from
American Colour

Source/Photographer:
Constantine Manos

Natural light, especially bright sunlight, will always create patterns that follow the random forms of their subjects.

Infinite patterns

An infinite pattern is created by a multitude of similarly formed elements repeating within an image, but decreasing in size towards the centre or away to a vanishing point, or repeating without end.

These patterns often lead the eye inwards just as the spiral of a nautilus shell takes the eye from the widest outer point round and round into the smallest point at its centre. If you hold two small mirrors opposite one another, you'll be able to see how an infinite pattern is generated by a seemingly endless repetition of a reflection of itself.

Spirals or circles within circles appear to continue inwards towards infinity. Other non-symmetrical patterns appear to radiate away from a start point in multiple reproductions of itself (and here, the sense of infinity can only be implied since every page in a book ultimately has to contend with the boundary lines created by the page edges).

Fractals and Mandelbrot images show in incredible detail how, once the image is zoomed into, a repeating pattern can continue into infinity. These impressive and dazzling computer-generated images are not a new invention by any means. The worlds of ancient art and religion, such as Buddhism and Islam, are strewn with examples of beautiful infinite patterns.

Fractals and Mandelbrot images

Fractals are curves or geometrical figures that are useful in modelling structures in which similar patterns recur at progressively smaller scales (snowflakes, for example).

Benoît Mandelbrot is a Polish-born French mathematician, who is known as the pioneer of fractal geometry.

Title: Fractals

Source/Photographer:
Jeremy Webb

These images were created with the powerful Photoshop plug-in, Kai's Power Tools, which allows the creator to experiment with fractal images. Fractal patterns show complex patterns that duplicate and repeat themselves infinitely.

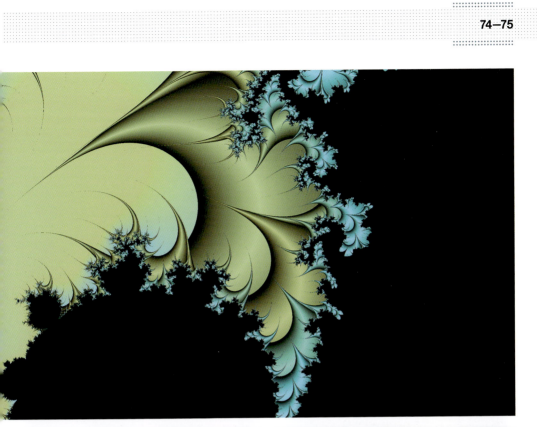

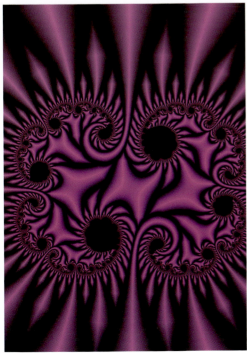

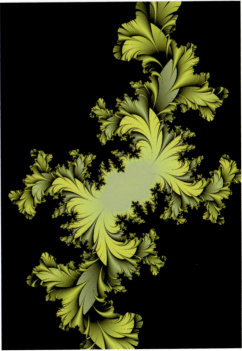

The idea that a single element can be repeated again and again within an image is one that photographers have embraced with enthusiasm. The technique seems to lend itself easily to the medium of photography.

Faced with a military parade, what would many photographers do? Shoot square-on to the line? Literally capture an image of a row of ten or more identical soldiers? This might convey the impression of military precision and pride, but other photographers, keen to create a different type of image, might nip to the end of the row and shoot 'down the line' to create an image of one soldier endlessly repeating into the distance, until the end of the line is reached. Such an image would contain the whole line in one image AND create a repeating pattern of a more dynamic nature than simply shooting a portion of the soldiers square-on.

Repetition has its uses, but it can be overused by photographers who sometimes retreat into tried and tested territory instead of summoning up more creative responses, or simply telling it straight. It is much better for your subject to determine your approach, rather than approaching your image-making by formulaic techniques or easy solutions.

Shape

If the repetition of a single shape or form is the aim, it helps to fill the viewfinder completely. Some shapes are instantly recognisable as silhouettes. An ordinary fork, for example, is almost impossible to perceive as anything else. Other 'non-objective' or abstract shapes can be repeated through the medium of the photograph and their representational ambiguity becomes intriguing to the viewer. The repetition of a single strong shape can significantly amplify your photographic intent.

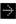

Title: Red – Sally Advertising 2009

Source/Photographer:
Steve Hart

Repeating shapes can create striking designs, especially when combined with a powerful colour.

Line

Many photographers at times enjoy the opportunity of developing what may be termed a more 'graphic' approach to their work. This often involves a self-motivated initiative to capture images that include the repetition of line.

Lines not only define the boundary area within which an image is created, but the simple act of the placement of a line within that boundary is one that can profoundly affect the visual appeal and impact of the image as presented within a rectangular frame.

The six figures on the facing page illustrate how lines can dramatically affect the composition and feel of images. Figures 1 and 2 show how vertical and horizontal lines can appear passive within the frame, mimicking the top, bottom or sides of the frame, by being placed in a parallel position to the edges.

Figure 3 shows how a diagonal line creates a dynamic effect that is quite different from the other examples. It immediately appears more energetic, implying a division of the frame into triangular sections rather than creating further rectangular shapes.

Figures 4 and 5 show how repeated horizontal or vertical lines, while they impart a sense of unity and harmony in their composition, amplify their own static or fixed appearance.

In Figure 6, the repeating diagonal lines retain the same sense of unity, but create a more forceful impact.

The simple act of placing a line within a boundary is one that can profoundly affect the visual appeal and impact of an image.

Figure 1

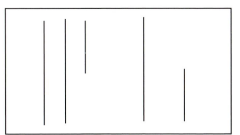

Figure 4

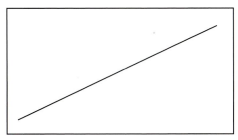

Figure 2

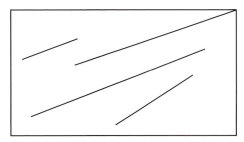

Figure 5

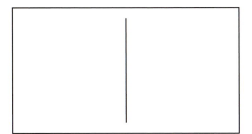

Figure 3

Figure 6

Motif

The use of a motif in photography enables photographers to link their images thematically through the use of a single repeating idea or element. This is much wider in scope and ambition than the use of a simple recurring pattern or shape because the motif itself is representative of a more complex idea or concept, and has the power to bind together an exploration of that concept across a range of images.

Many of the great photographers build reputations and valuable collections of their work precisely because they employ their powers of enquiry to explore single themes or concepts throughout their careers. For example, the overlooked lives and landscapes of suburban America were central themes to Gary Winogrand's work. Fay Godwin produced work inspired by the mark of humankind on the British landscape, while Robert Doisneau told memorable stories of life in the streets of Paris in the 1940s.

Motifs can also be useful in producing smaller sets or a series of images – it can act as the conceptual glue that holds a collection of images together within a single project.

Motifs and symbols

A motif is a single or recurring image forming a design; it is a distinctive or dominant theme in a work of art.

A symbol represents or stands for something else – a material object representing something abstract.

Title: Ribbons

Source/Photographer:
Jeremy Webb

A series of images inserted into a grid formation like this can create both an image in its own right, or a display of several separate images.

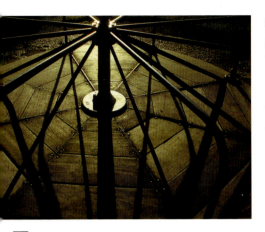

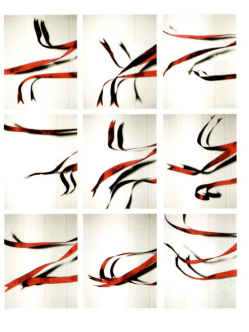

Title: Eaton playground roundabout

Source/Photographer:
Jeremy Webb

Shadow can play an active part in a composition. Here, it is used to help create a pattern of straight and angular lines by shooting into the light.

Symbol

Symbols appeal to photographers because they employ a separate, but distinctive visual language which, like photography itself, requires decoding and deconstruction in order to be properly interpreted.

Symbols represent something. They usually appear as a simplified code for something else. A simple thumbs-up sign, for example, is code for 'OK'. The use of symbolism in photography allows photographers to add complexity to their imagery. This might, for example, slow down the viewer's interaction and reading of the image by having to penetrate additional layers of meaning.

Great care must be taken when using symbolism since cultural specificity comes into play and not all symbolism is universally understood. In fact, symbolism understood in one culture or continent could mean the complete opposite in another. The colour red, for example can signify danger, life, or sexuality depending on its use and context. In eastern cultures, for instance, the colour red may refer to luck or fortune, but it could signify danger in other places.

The use of interruption as a design technique works on several different levels. At its simplest, it is the intentional or unintentional use of a single element that breaks the continuity and harmony of an otherwise flawless or ordered unity. In visual terms, it's the pebble thrown into the still pond, destroying the calm and creating ripples.

Disruption of order

Interruption forces you to confront a harmonious pattern that appears perfectly unified were it not for a single element which resolutely refuses to conform to the rest of the image or work. This small act of 'rebellion' can force you to examine the element itself (if this is the intention), or to ask questions of the context or harmonious environment into which the non-conformist element is placed.

Its emotional effect can be felt in much the same way that musicians sometimes talk of dissonance – a lack of harmony or a tension created by the collision of two unsuited elements. Creative artists understand that a single element disrupting the order of an image or work can be a very useful prompt. In design terms, it simply makes the viewer sit up and take notice.

Title: Mono multi-ripples

Source/Photographer:
Jeremy Webb

Across a pattern of undulating horizontal lines, a single vertical spike effectively interrupts the unity of this image and creates a point of interest in an otherwise monotonous scene.

Creative artists understand that a single element disrupting the order of an image or work can be a very useful prompt.

We've referred to 'a sense of unity' several times in this chapter and in looking at a range of design principles so far, the concepts of variety and unity are critical to an understanding of the way that design works within photography.

Variety comes from elements of different shapes, forms and textures grouped together. Unity comes from a sense of sameness or togetherness – a feeling that the elements presented within the image somehow belong together. This could result be achieved by either creating a pattern of similar repeating shapes, or by creating a design of different hues or strengths of the same colour.

Sameness and uniformity

Too much of the same thing can get a little dull and yet there's no denying the appeal of a pattern or a symmetrical design from which we enjoy a sense of harmony or order.

A repeating pattern can be reassuring. The sameness and unity of the elements within the image are ordered, certain and predictable. However, the use of this very sameness can also lead to a sense of repetitive tediousness.

Sameness often prevents a central motif or single subject from standing apart from its background or environment. By not allowing a single element to break out from a uniform arrangement, creative possibilities are limited to occasional use – we must remember that this is a creative strategy that could be effectively applied to images.

Difference

Variety or difference allows comparisons to be made between elements within an image. On the other hand, too much variety can lead to a chaotic image and your audience can become confused: Where am I supposed to look? What is the photographer's intention here? The use of variety must be well considered and balanced.

Variety can be employed as a much-needed balancing mechanism in an image too richly unified. Like the Taoist yin and yang symbol, sameness and difference are interlinked and inseperable. An image that is too unified requires an element of difference before it really comes to life. By the same token, an image that is chaotically complex can be calmed by the use of a unifying element.

Title: Geoffrey

Source/Photographer:
Greg Funnell

This beautiful portrait evokes a kind of natural sincerity and emotional warmth resulting from the skilful blending of a number of key design ingredients: soft lighting, small depth of field, frame-filling composition, and the sympathetic use of colour on the pale green shirt and the natural skin tone.

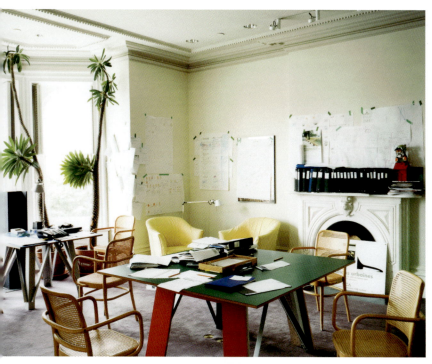

Title: Director's room

Source/Photographer:
Naoya Hatakeyama

This intriguing interior contains many elements and shapes that repeat, such as chairs, box files, plant forms and tape on the wall. Crucially, this busy image also contains elements that have no duplicates at all, but stand alone to add interest to the complex variety of shapes and colours which jostle for our attention within the image as a whole.

This series of images by Osman Ashraf beautifully demonstrates how a simple theme (hands) can generate a creative and stylish response and how design principles support the intention of the photographer.

In this collection of images, texture, positioning, light, viewpoint, colour strength, emphasis, the unity of the set, and a photographer's ability to apply simplicity with clarity have all resulted in a beautiful set of images that remain linked by theme and style.

By adopting several viewpoints that add depth to the scene, the photographer increases our involvement within the images he creates. This is achieved by including foreground subject matter close to the camera, which then leads towards background subject matter providing greater context and meaning. We're invited to go on a journey, however briefly, between near and far.

Lighting, too, is critical to the set. Sunlight illuminates the hands and face during prayer; light bounces off the frets of the guitar to increase contrast; and the texture of the hands holding the coffee mug is softly lit.

Title: Untitled

Source/Photographer:
Osman Ashraf

By adopting a variety of different viewpoints, Osman Ashraf has captured a strong series of images showing how hands are used in various everyday situations.

Case study 3
Depth and light

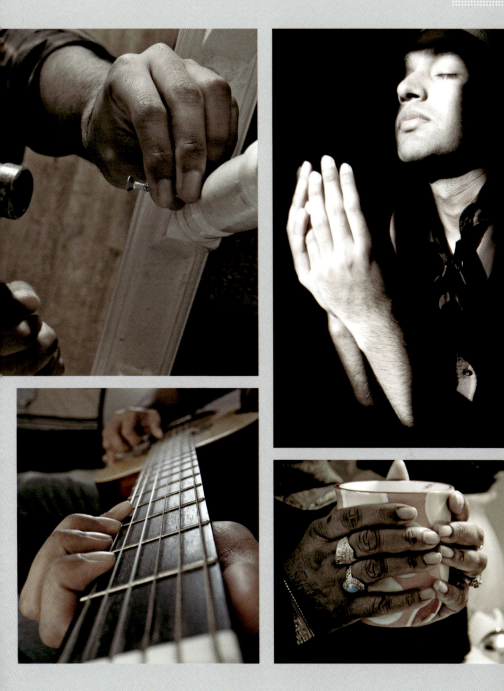

For an image to have rhythm, it must somehow have a pulse. In musical terms, rhythm is used as an underlying beat or structure upon which a melody is placed so that the piece proceeds at the same speed or intensity, ensuring that the sounds made are not chaotic or discordant.

In photographic terms, that pulse can be generated in a variety of ways: a harmonious arrangement of objects equally spaced; a repeated motif suggesting a recognisable pattern; a familiarity throughout the image. Photographers who are skilled and design aware are always in touch with a range of design principles that foster this ability to create rhythm.

Patterns, repetition and the skilful manipulation of shape or form can all be applied to create a visual rhythm. Rhythm is most apparent when it consists of a sequence of peaks or stresses separated by pauses. While this is easier to see in musical terms as the notation on the page, a sense of rhythm can also be created visually through the principles of movement and flow.

Flow

The flow of an image is very much like its movement or rhythm, but it allows the viewer to navigate a gentle journey through the image without interruption or dissonance.

Skilful placement of two or three image elements can help to achieve a feeling of flow. However, it can also be achieved through the use of leading or gently curving lines that are harmonious and balanced within the image.

Title: Alicante, 1933

Source/Photographer:
Henri Cartier-Bresson

This image has sometimes been criticised for being staged in a way that is quite at odds with Cartier-Bresson's usual method of straight reportage photography. Whether this is the case or not, the image's humour and visual appeal make it a very popular and memorable image – an image where the concept of flow can be seen clearly.

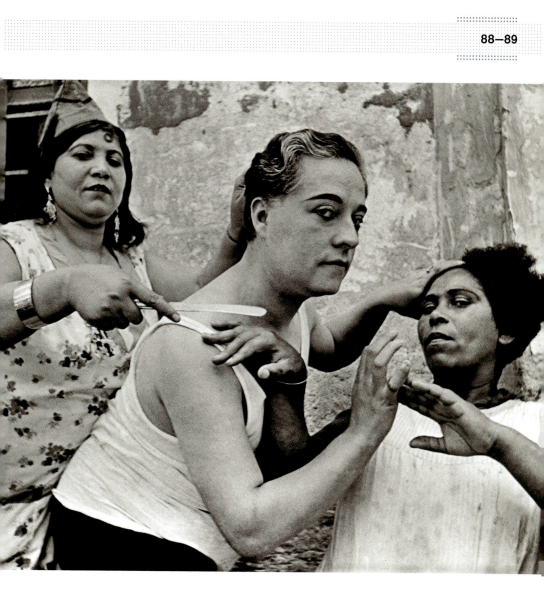

Rhythm is most apparent when it
consists of a sequence of peaks or
stresses separated by pauses.

Creating movement

Photographs are static objects, so how do we create movement? It's not so much about having a subject that moves. It's about how the eye is led and able to move around and within an image, and how a sensation of movement can be present within an image.

Sometimes, creating movement could be as simple as using a deliberate camera shake, slow shutter speed, or panning the camera to isolate a still cyclist against a blurred background.

Very powerful evocations of movement can be generated compositionally through the skilful placement of your subjects within the frame. For example, a golf ball lined up for the final putt can be placed at one side of the frame, with the destination hole at the other side of the frame. The green space between the two elements takes centre stage within the frame and the viewer rolls the ball into the hole using his or her imagination.

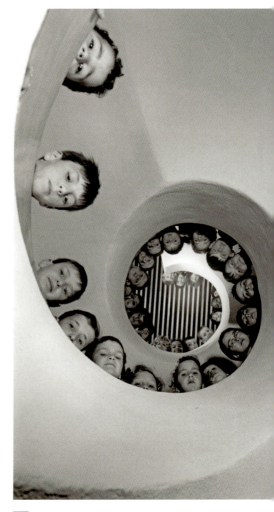

Title: Library for children, Clamart, 1965

Source/Photographer: Martine Franck

A simple spiral shape demands that the eye follows the line to its conclusion within the centre of the image.

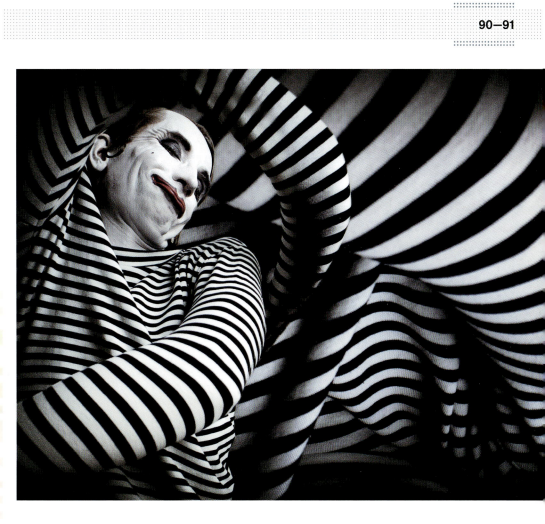

Title: Stripey clown

Source/Photographer:
Luka Kase

A fluid, circular rhythm takes the
viewer inside this image where
repeating elements of the black-
and-white curved stripes motif
provide a distorted sense of space.

In photographic terms, contrast is all about the difference between one thing and another. It is usually used when describing the difference between tones. In the broader sense of the term, contrast can be used to describe differences between colours and subjects within an image that feature differing properties or characteristics (see also Juxtaposition on page 148).

Creating movement

The concept of contrast is simple to grasp when it relates to black-and-white photography – it is created by light reflectance and refers to the degrees of difference between dark and light tones. On the other hand, there are several ways to explore contrast in colour:

Colour saturation or intensity can be a powerful tool with which to make a bold statement. Bright, clean yellows or reds, for example, can grab our attention and force us to look in a way that softer secondary colours or pastel hues cannot. However, this does not mean that you cannot combine the two. Striking contrasts can be created by placing a strong primary colour against a quieter colour, but care should be taken to get the balance right.

Complementary colours appear on opposite sides of the colour wheel (see colour wheel on page 62). These combinations often create the most immediately visible contrast even if they appear to be of equal colour intensity, for example, blue against yellow or orange. The human eye has great difficulty accepting and absorbing the light wavelength of each colour simultaneously and this sets up a tension as the eye tries to process and cope.

Opposing colour temperatures can create contrast between warm and cool tones. Warm tones can evoke an emotional response of a welcoming, positive nature, whereas cool tones can make a person feel slightly ill at ease and chilly. Warm colours are often referred to as 'active' due to their ability to draw attention. Cooler blues and greens are often said to be passive as they appear to withdraw or support stronger and more active colours.

Subtle colour contrast can be achieved by utilising combinations of colours nearer to each other on the colour wheel. Quiet, restful images can be created by carefully selecting colour combinations that appear to have similar tonal brightness or somehow balance each other in terms of their intensity or saturation.

Title: Apples and pears

Source/Photographer:
Jeremy Webb

This image illustrates everyday subjects that blend and contrast well with each other.

Tone

Tonal contrast in photography relates to the difference between highlight and shadow – between dark and light.

A high-contrast image will have rich, dark blacks and punchy, clean whites, and although it may contain recognisable detail within the midtones, some detail will be missing; its tone sacrificed for a grittier, more 'contrasty' image.

A low-contrast image is one where greater emphasis is placed on the differences between midtone greys, sacrificing some of the rich dark blacks and clean whites in the process.

Most photographers strive for a balance between the two, aspiring to the punchy immediacy and primary impact of a high-contrast image, but wanting to retain the clarity and secondary appeal of an image within which every detail is visible.

Modern digital image-editing software can easily accommodate this requirement by allowing photographers to merge two or more exposures within one final image. However, there are times when an image can have more appeal if it remains one thing or the other, encouraging the brain to fill in the gaps in a process of imaginative expectation, rather than expecting the viewer to accept an image that is clearly too perfect.

Title: Apesanteur

Source/Photographer:
Pascal Renoux

Black-and-white subjects allow us the opportunity to study differences in tone and contrast without having to negotiate our first impressions of an image dictated by our responses to colour.

Subject

Contrast between different subjects allows photographers the opportunity to play with our sense of world order. If one of photography's major achievements is to enable us to view the ordinary in extraordinary ways, then placing one subject with another (or against an unfamiliar background) to create contrast is simply a continuation of that noble ambition.

Take a small grapefruit, place it on a simple white dinner plate and shoot from above. Most of us can imagine this scene. Place the grapefruit on a square plate and you increase the contrast between the fruit and plate further – a right-angled shape supports a circular form. Increase the contrast even further by shooting the grapefruit on a blue square dinner plate. How far can you push it?

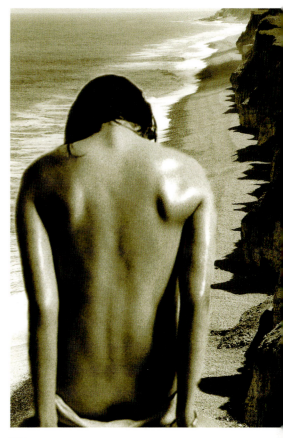

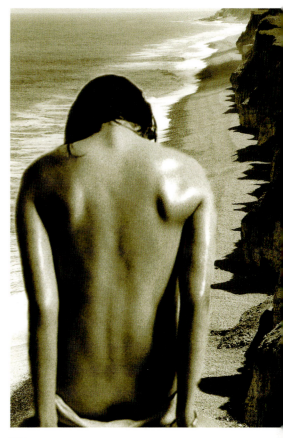

Title: Cliff top vertigo

Source/Photographer:
Jeremy Webb

This is a deliberately ambiguous image that contrasts the soft, rounded form of the body with the angular and pointed shapes created by cliff shadows cast on the shingle beach.

Take a group of similarly shaped and similarly sized pens and pencils, or a pile of a dozen books.

Using a range of design principles discussed so far, proceed to create a set of six images that respond to the themes set out below:

Pattern

Tessellation

Interruption

Movement

Symmetry

Asymmetry

Guidance

Think carefully about the wealth of design tools and techniques at your disposal: lighting, composition, colour, line, shadow, space and depth of field. Any or all of these (and more) can be employed to create a set of dynamic and artfully constructed images.

The subject matter itself may not set the world on fire, but this is simply a focused opportunity to play with basic design principles in order to develop awareness and design skills by having a good workout in the 'creative gym'.

The images here are examples of ideas generated in the formulation of a photographic response to a book cover commission published by the Pen & Ink Press.

Exercise 3 Form and structure

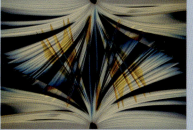

Title: Examples of tessellation

Source/Photographer:
Pen & Ink Press

Some of the design ideas generated here show initial ideas in response to the book title, *Tessellate*, which means to produce an image via 'the repeated use of a single shape, without gaps or overlapping'. The finished image of fountain pen nibs interlocking to create a background was darkened and softened in order to create good separation between the typography and the cover image.

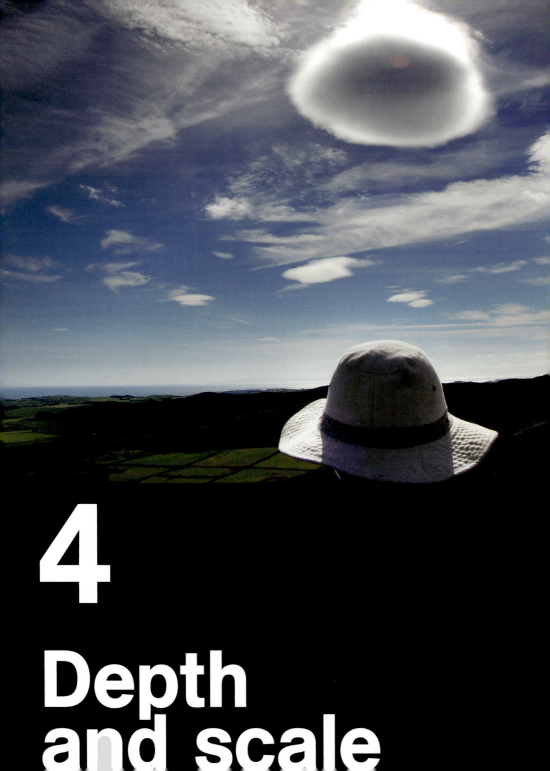

4

Depth
and scale

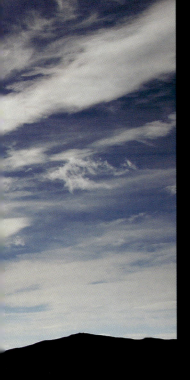

Title: Blob cloud and hat

Source/Photographer:
Jeremy Webb

Sometimes the eye is constantly
moving between two competing
elements within the frame in order
to determine the spatial relationship
between them.

**Without a doubt, one of the most
frustrating aspects of photography
is the inability of a photograph to
break free from its own inherent
flatness – its two-dimensionality.**

To state the obvious, a two-dimensional
print representing a small portion of the
three-dimensional world is always going
to disappoint if we don't accept and try
to work within its limitations.

Our imaginations are very good at
interpreting a sense of depth when
we look at a photograph. Distances
between objects and relative scale are
all calculated by instinct and judgement
without us being truly aware of the
process. Thus, we construct invisible
layers of depth or markers that denote
perceived space and distance in an
attempt to circumvent the limits of
two-dimensionality.

Skilled photographers, being finely
tuned to this issue, have become
adept at working within conventional
design principles to manufacture
depth. There are a number of skills and
techniques that can be used by any
photographer to increase the appearance
of depth in their photography.

Compositional skills are one of the primary techniques that can overcome a photograph's limitations. The ability to place and position major elements in your frame, which lead or guide the eye through a scene, is preferable to merely dumping your viewer in front of a flat focal point. This does not give the imagination much to feed on and the viewer quickly loses interest.

There are other more immediate factors that lie in wait for photographers even before the viewfinder is raised to the eye, and these will be discussed in this section.

Using light to achieve depth

Photographers often talk about light in terms of the physical properties they reveal and their effect on a subject's appearance. 'Flat' light often results from a light source that may be quite strong, but is diffused and comes from a broad origin and from an angle close to the axis of the camera or the subject.

Overcast skies can produce this kind of light and may provide plenty of illumination; however, it does not provide much in the way of contrast. Contrast, which we looked at in the previous chapter, helps to define separation between different tones, increasing our appreciation of a subject's three-dimensionality.

Photographers can use flat lighting for a range of purposes. It's often used in fashion and beauty photography precisely because it is soft and does not reveal wrinkled textures in skin or materials. It lights evenly and creates minimal shadows. In a studio, the effect is often created by the use of a soft box, which provides even, fairly shadowless light.

A low, raking light will provide just the opposite. This kind of lighting, in which a bright, single source of light is held low and to the side of the subject, will highlight every peak and leave long, deep shadows in any dips or troughs on a subject's surface. The effect highlights texture and amplifies our appreciation of the subject's surface or form. This kind of light might be used to highlight wrinkled or craggy skin in a character portrait, and can be easily created in the studio using bright light sources such as spotlights or even slide projectors. In nature, it can be seen from the low light of a setting sun against the rough bark of a tree.

Title: Sand ripples

Source/Photographer:
Jeremy Webb

Backlighting and a low angle of view can also be used to increase the sense of depth within an image. Here, the low light only allows for a wide lens aperture, which produces narrow depth of field effects.

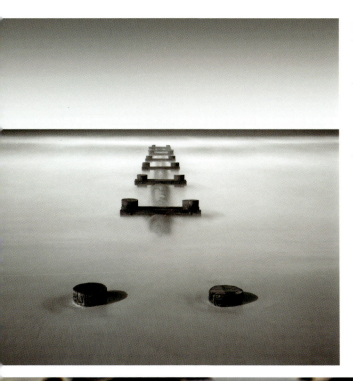

Title: Pipeline, 2005

Source/Photographer:
Michael Levin

The sense of space created by the breakwater structure extending away and into the horizon creates a necessary degree of depth to this image. It helps to alleviate some of the limitations of the two-dimensional 'flat' image.

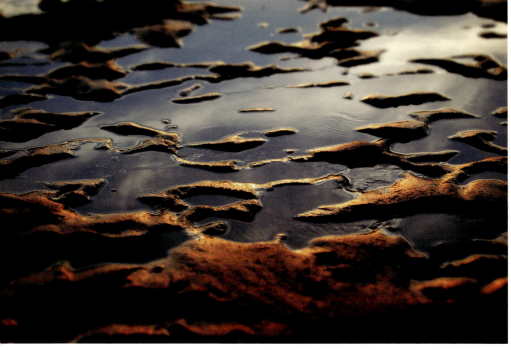

Content and context

A subject that stands apart from its background is said to show good foreground/background separation. This is a fundamental concept in design and photography and it's critical to our appreciation of the spatial separation between a subject and its setting.

In most cases, of course, the main subject of an image will always be in the foreground, and the setting or environment it exists within will be the background. But creative opportunities exist to overturn this dual relationship and reverse the conventional arrangement by shooting beyond a foreground subject (by using deliberate blur or de-focus), guiding the emphasis of your image towards the background as subject.

Title: Handcuffs

Source/Photographer:
Oliviero Toscani

The international success of Benetton's advertising campaign images is not solely down to shock value and controversy. By carefully stripping away everything that is superfluous and unnecessary, the image content is always direct and economical, allowing the visual message to carry its power without ambiguity.

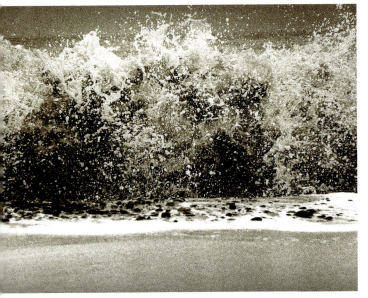

Title: Crashing wave, Scratby

Source/Photographer:
Jeremy Webb

For certain situations where fast movement and unpredictability occur, the autofocus function of many modern digital cameras will be useless. It is far better to pre-focus manually where the action can be predicted to occur.

UNITED COLORS OF BENETTON.

The limitations of autofocus and autoexposure

These days, modern cameras are packed full of circuitry and fail-safe devices to ensure that a photograph can be captured with as much clarity as possible, at all costs. There are anti-shake modes, and exposure modes pre-set by manufacturers for landscape, portrait, close-up, and even sunny or cloudy weather photography. Of all these different 'helpers', the mass adoption of autofocus and autoexposure has been the most widely accepted – however, these tools could also be the most detrimental to creative photography.

Without a doubt, both modes will help get you out of a hole. And if you have to get that once-in-a-lifetime grab shot, why would you shoot in any other way? But more often than not, we have far more time on our hands and have simply become lazy – we rely on autofocus and autoexposure to do all the work for us. This hardly encourages us to apply our own choices. Automation often reduces our power to influence some of the most basic techniques in photography. The simple user-controlled techniques often genuinely liberate our creativity and individuality. Sadly, we're often happier remaining enslaved to all things automatic.

Title: High-wire walker

Source/Photographer:
Jeremy Webb

Foreground information helps the imagination to assess depth and distance within an image.

Real depth can only be experienced. The initial sensation of being aware of our own position within an environment is quickly supplanted by the realisation that distance extends outwards from our position in all directions.

Sometimes an image that does not engage us so often simply lacks a sense of depth. Its subject may be of interest to us, the arrangement of different elements within its composition may appeal, but something about the image makes us feel we're being offered a bland snack when what our imaginations crave is a feast.

Photographers have at their disposal the means to create that feast by adopting a viewpoint, distance, and degree of coverage of that emphasizes depth. Since any photographic image is two-dimensional, the depth created is illusory, but this is not to say that it cannot convince the eye into believing that it is something greater. There are many ways to achieve this.

Foreground and background separation

As we've seen, this refers to the means by which the main subject of your image stands out from its environment or background. Photographers should be aware of the elements of design that strengthen the degree of separation between foreground and background, thus increasing the perceptual depth within the image. Many of the design elements we've looked at can boost foreground/background separation: contrast, complementary or competing colours, and textural differences to name a few.

Sometimes the lack of separation can also create an appealing image. A sense of mystery or abandonment may draw us in where layers of depth are hard to perceive – a foggy scene of trees, for example, where individual elements may seem hard to locate in relation to others.

Title: Vivienne Westwood

Source/Photographer:
Mark Johnson

Foreground and background separation can be strengthened by using a longer lens (higher focal length) whereby depth of field effects can be better used to blur the background. This wonderful portrait of Vivienne Westwood also shows an interesting blending of colours: the more saturated, vivid colours of her hair and knitwear are in the foreground, while the more subtle colours of the urban browns and green are in the background.

Positioning of picture elements

Many successful photographers make use of our sophisticated sense of perspective and space by skilfully placing a series of elements or points of interest at varying distances throughout the frame: foreground, middle and far distance. These points of interest anchor our gaze temporarily and allow us to wander through the image in a route organized by the photographer.

The careful positioning of elements is much easier to achieve and conceive where images are planned and prepared from the start. Still life is a good example – photographic image can be built from scratch instead of attempting to manipulate multiple elements and points of view 'out in the field' where this may be physically impossible or simply impractical.

Use of depth of field

Perhaps more than any other technique, photographers should be aware of the principles behind depth of field. Light, lens focal length and lens aperture (the size of the hole used by the lens to gather in the light required to create an accurate exposure) are critical to the amount of sharp focus within the image.

Small apertures of f16 or f22 will provide maximum depth of field (good focus from near foreground and extending into distance) whereas larger 'holes', such as f2 or f4, will provide a very narrow band of sharp focus – items in the near distance and far distance will be out of focus.

Wide-angle lenses will allow greater depth of field at large or wide apertures, but they can also distort our sense of perspective, scale and spatial relationships. Telephoto lenses are less tolerant of large or wide lens apertures and focusing becomes more critical – although narrow depth of field can easily be achieved.

Why is all this technical detail important? Depth of field assists our imaginations in perceiving depth within an image by conferring emphasis (sharp focus) on part or parts of an image we want to underline. This therefore gives less importance to elements that are in blurred or de-focused areas.

The careful positioning of elements is much easier to achieve and conceive where images are planned and prepared from the start.

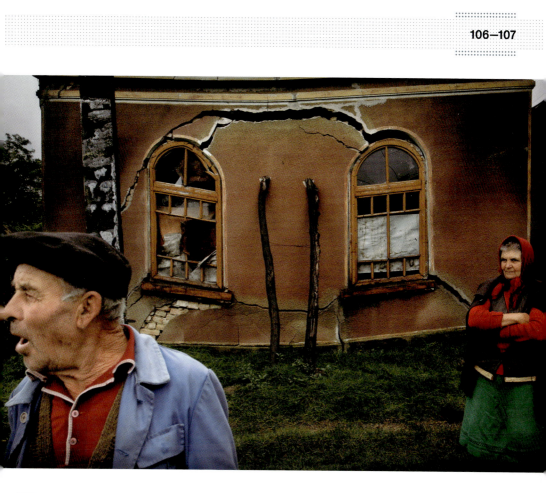

Title: Romania, 2005

Source/Photographer:
Tamas Dezso

Placing figures at either end of the
frame and at different distances
allows the eye to switch between
the two elements and explore the
background in between.

False attachment

This is a neat trick occasionally used by photographers who enjoy the opportunity to play with our knowledge of two-dimensional flatness and three-dimensional reality. It requires two planes of distance – near and far – and creates the illusion that near is as big as far, or that far is as near as big. In effect, it attempts an optical illusion by suggesting that both foreground and background actually share the same scale and distance to camera. Our brains, however, unpick this deception and quickly separate both planes of depth, and so we simply enjoy the joke.

Down the line images

Imagine a row of bottles on a windowsill. Do you shoot them head-on? Do you simply frame them all, equally sized, all lined up from the left-hand side of the frame to the right?

A slightly more creative response might be to go to one end of the line and shoot 'down the line', allowing some bottles to stay in focus whilst other drift out. This then creates the illusion that each bottle is a different size even though this is simply the result of similarly sized objects receding in apparent size due to the effects of perspective.

This kind of approach may seem obvious and simplistic, but there's a world of difference between the results of the two approaches. One appears flat and uniform, its ordered pattern is monotonous; the other approach is more likely to generate an image with a greater sense of depth.

Title: False attachment

Source/Photographer:
Jeremy Webb

Simple optical illusions such as this combine near and far subject matter that seem to share the same distance to camera.

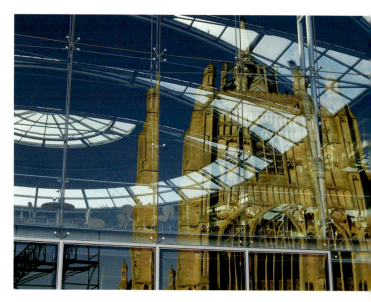

Title: Reflection of St Peter's

Source/Photographer:
Jeremy Webb

Both the old and the new can be brought together in different layers by using reflections in the urban environment.

Layers, reflections and multiple exposures

Layers created by reflections allow photographers to project more than one meaning or interpretation to their image while at the same time inviting the viewer to perhaps switch between messages.

The degree to which different layers of meaning or intent become apparent can be harnessed by a skilful photographer to create a sense of depth. It is a delicate process and the photographer must ensure that the image does not become muddy or indistinct. Careful judgement is required in order to attain an image that is not too complex or unreadable.

Multiple exposures have always fascinated photographers of a more haptic nature, and have been used from the earliest beginnings of photography. Used successfully, multiple exposures can create an impression of depth as the eye switches between the exposures. However, one must bear in mind that if the result of such conglomerations are too random or unsuited, confusion and frustration can often result.

Scale allows us to view the size of something compared to a 'normal' or 'average' model. Most photography represents the scenes and subjects we witness on a daily basis as they are, but photographers have an opportunity to use scale as a design tool in order to force us to view a subject in a completely new light.

The importance of scale to perception

The willingness with which we can accept exaggerations of scale (both normal to small, and normal to large) depends on many factors, not the least of which is being able to judge the intent of the photographer or image-maker.

If it's felt that the photographer is simply trying to deceive us with image trickery (by digital image editing, for example) we may not buy into the vision and reject the image, deeming it too absurd or ridiculous. But if we enter into a kind of contract with the image creator through a shared sense of fun, we can accept the deceit and take part in its obvious manipulation.

Title: Albuquerque, New Mexico, 1957

Source/Photographer:
Garry Winogrand

Winogrand intuitively captured moments of ambiguity or uncertainty in his work. In this image a small child is emerging from a vast dark interior into a sunlit world where there appears to be no boundary between the safety of home and the great wilderness on the doorstep. The child's size and proportion in relation to everything else within the image is what gives this photograph its power.

Title: Supergirl with giant silver shoe

Source/Photographer:
Steve Hart

Visual deceptions and tricks that exploit our ability to perceive size and scale are a favourite technique in advertising photography – it has the ability to grab our attention.

Foreground and background separation

Proportion, like scale, is often measured against a scale of 'normal' values. It describes the size of something in relation to this fixed idea of normality. In photographic terms, it not only describes the disproportionate relationships between shapes or forms having extreme differences, but also describes subjects whose distance to the camera (and therefore whose size within the photographic frame) may be termed disproportionate.

Such techniques, whether manipulated or accidental, can create wonderfully intriguing imagery as the brain attempts to make sense of the differences between the apparent size of something against what is expected.

Photography has always enjoyed a tenuous relationship with truth. Subverting expectations and assumptions by manipulating size or shape proportions is another means of exploring the medium creatively.

Title: Tunnel #2, 2003

Source/Photographer:
James Casebere

Casebere exploits to the full our willingness to accept the photographic 'truth' of his meticulously crafted and beautifully lit interiors. As real and as life-sized as they appear to be, they are in fact created on a much smaller scale within a studio. The photographer's use of lighting, the creation of depth, the absence of any superfluity or detail, and his colour palette all combine together to create these emotionally charged interior scenes, which evoke some powerful and perhaps unexpected emotional responses in the viewer.

Photography has always enjoyed a tenuous relationship with truth.

Photography student Sanette Blignaut shot a series of fashion images to show a range of garments in the outdoors. Aside from being beautifully styled, the images project a confidence and professionalism resulting from many factors — most of which are the result of careful consideration given to design principles. The natural setting works sympathetically with the clothes, and the make-up colours used complement the colour palette within the images.

The image on the top left shows good separation between foreground and background as provided by the depth of field, allowing the background to go out of focus, which in turn projects the model forward.

The image on the top right is rich with texture: the smooth skin on the model's face, the hat, her hair, the pleats of the coat and the bark of the tree. The light appears to be coming from strong sunlight above and to the left of the model. This has been softened by a reflector, which bounces the light back towards the shadow side of the model's face. Another intriguing shadow is cast by a single strand of hair, creating a point of interest.

The image on the bottom right manages to create a sense of depth through the use of a wooden gate or fence that leads from foreground to background. Again, the separation between foreground and background is evident, and the hazy sunlight from the right-hand side casts a bright, but soft light on the model.

The image on the bottom left is a good example of creative rule breaking. Not only has the model's face risen disproportionately to the top of the frame, but the top of her head is also cut off by the edge of the image. What works, however, is the balancing act between two areas of interest and the space in between. The model's face appears at the top of the frame while the detail of the garment and some beads appear at the bottom. Subject matter of primary importance is usually placed in or near the central area of the frame, but here, the space is used as a gap to separate the two primary areas of interest, allowing the eye to switch between them and explore other elements nearby.

Case study 4
Style
and setting

Title: Fashion images

Source/Photographer:
Sanette Blignaut

The suitability of the environment is critical to our reading of images. The backgrounds and natural textures of the woodland used for this series work in harmony with the clothes and make good use of the natural light available.

Playing with scale allows the photographer to mask or obscure the obvious. In practice, many subjects can be photographed from a range of distances. This allows us to take good, clear images that show the subject within its environment. These images can be taken at a sensible distance to render the subject at a proportionate size within the frame.

On the other hand, we can do without proportionality altogether, and through the use of lenses, viewpoint, shooting angle or distance, completely obliterate any sense of scale.

Disorientation

Abstract photography can be so compelling because it provides no sense of scale or proportion. This leaves us floundering. However, the brain is determined and programmed to make sense of the most bewildering of circumstances. Being able to let go of rationality and an analytical deconstructive approach to abstract images is easier for some than it is for others. We still live in a world where everything has to be explained.

The ability to let go allows us to view and appreciate a scene that doesn't make sense at all. It is possible to find great beauty in unanswered questions or the unexplained – being lost is sometimes a great place to be.

Reference points

Like anchors in a storm, reference points give us a clue or a sign that help us to make sense of a disorientating image. Once these points are found, the eye and the brain start to understand what it sees.

An image of bare golden desert at sunset could be taken from an aeroplane above to create an interesting pattern of light and shadow, dips and rounded bumps, and a beautiful golden texture. And yet, place this image in front of someone who is unaware of the subject or the circumstances and they might think it is an image of a square foot of sand right next to the photographer's feet.

Only a reference point, such as the long shadow of a desert camel or a small oasis, would break up the unity of this particular image, providing an instant marker with which to assess scale and proportion.

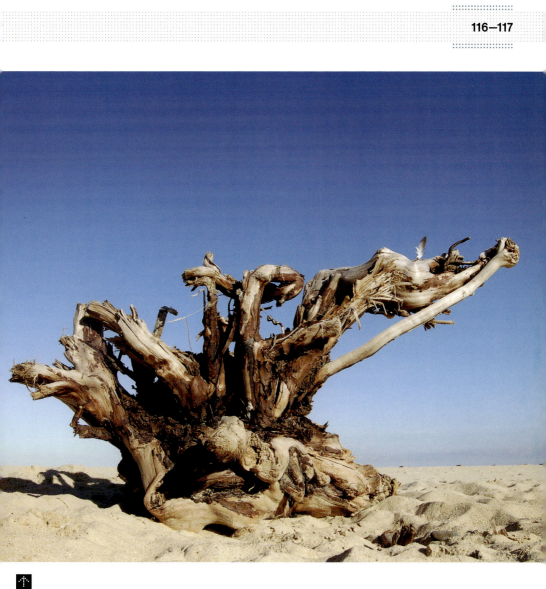

Title: Wood, Winterton

Source/Photographer:
Jeremy Webb

The absence of any recognisable scale can act powerfully on our reading of an image.

Abstract photography comes from an expressionist approach to the medium, and its relationship to scale deserves a closer look. It may be most visible in the fine-art world, but commercial photography has often used abstraction as an artistic way to express bigger concepts. In car advertising, for example, where the camera pulls away from a single droplet running down a beautifully waxed bonnet to reveal the car in all its glory.

By proximity with subject

In Chapter 1, we looked at how the edges of the frame can define objects in space and how a rational understanding of a particular scene can be reached by the way we organize the various elements in our images.

If we show an object without its edges, it becomes unfamiliar to us and we become lost. This forces us to observe the object's substance rather than its shape or form. Abstract images provide us with an opportunity to take pleasure from the observance of resulting design elements such as line, colour and texture. Abstracts are a wonderful way of keeping photographically fit – we are forced to exercise our creative muscles by creating meaningful imagery from the most unpromising of subjects.

Telephoto lenses can take us artificially closer to a subject due to their ability to condense and reduce a scene and fill the frame with many identical shapes, which result from a foreshortening of perspective. Subjects or elements that might appear more widely dispersed with wide-angle lenses are still possible to capture provided that the edges of the scene or subject are excluded.

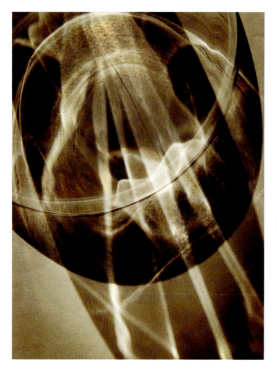

Title: Glass light

Source/Photographer:
Jeremy Webb

Abstracts often achieve an impact when scale and proportion are absent, forcing the viewer to focus on how the design elements work together.

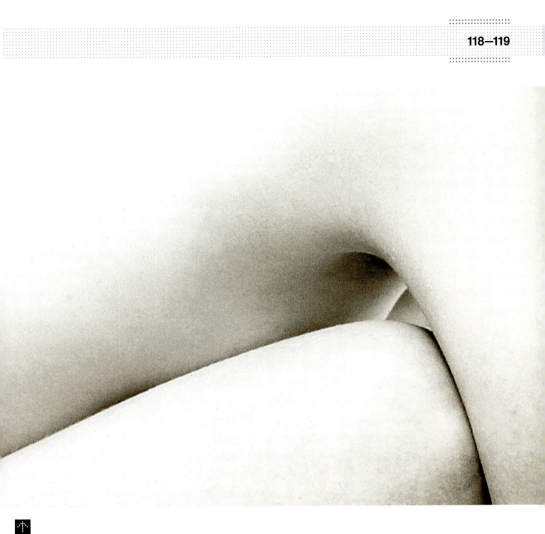

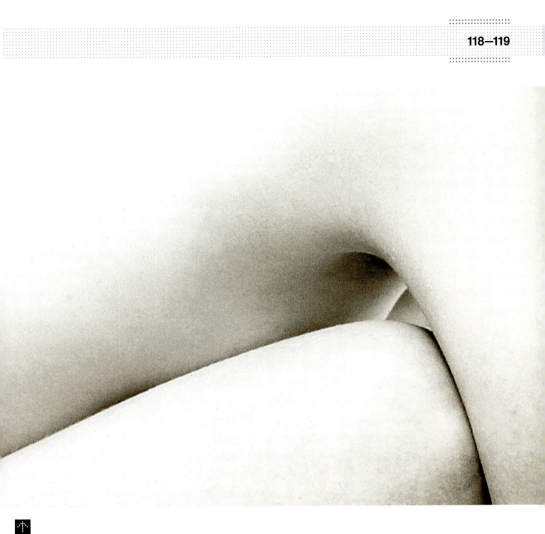

Title: Crouch

Source/Photographer:
Jeremy Webb

Getting closer to any subject allows you to create an abstract view that may have far more visual appeal than a more conventional shot from a greater distance.

By viewpoint

Altering your viewpoint is an easy way of creating abstract images – try adjusting your position in relation to your chosen subject.

Adopting a shooting position whereby a conventional framing of your image is deliberately obscured by competing elements will hide clues as to the real shape or form of your subject simply because its full mass cannot be seen.

Alternatively, use a low viewpoint in order to frame. For example, capture the bark of a tree against a bland white backdrop of sky – this is one way of avoiding all references to scale or recognisable matter, which may enhance a good abstract image.

By de-focusing

Allowing areas of your image to become unfocused can abstract a scene or subject forcefully or with great subtlety. Many photographers create intriguing abstracts by fully de-focusing the whole image, thereby putting conventional practice into reverse and deliberately reducing sharp detail to indistinguishable areas of blurred colour and form.

This process allows us to drop the intellectual and reductive approach to an image and simply enjoy the abstract arrangement of design elements, which have now come to the fore through de-focusing.

Through the careful use of depth of field, it is possible to control the amount of de-focusing in your image. You don't have to blur the entire picture for an interesting abstract to result – just taking the time and care to create intrigue and mystery can result from overturning the conventional methods – de-focus your foreground, focus your background. Rules are always there for breaking, provided you can justify your outcomes sufficiently.

Rules are always there for breaking, provided you can justify your outcomes sufficiently.

Title: Green III from the series Winterstille

Source/Photographer:
Christiane Zschlommer

Intriguing abstracts can be created by deliberately using de-focusing to disorientate the viewer. Used with strong colour, the effect is even more powerful, allowing the image to assert its design elements with confidence and integrity.

Title: Hammer head

Source/Photographer:
Duncan Loughrey

Lighting and viewpoint combine powerfully in this image. The handle of the tool is not necessary to include in the image once the simple form of the hammerhead itself is understood – the imagination does the rest.

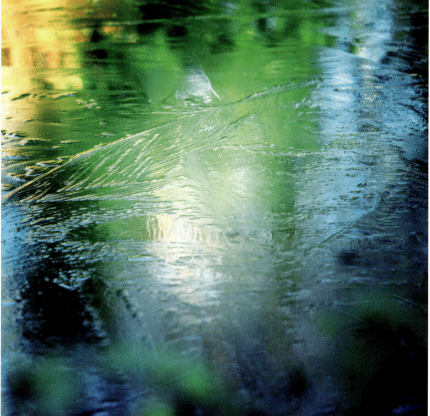

Abstract images, perhaps more than any other type of image, force us to examine the design principles that lie at the heart of their construction because a recognizable and specific subject is absent. What remains allows us to enjoy the more visible effects of design elements in all their glory.

From the interior and exterior environments around you (or from the list below), shoot a series of six abstract images that focus on a particular aspect of design:

1. An abstract image created by the play of sunlight upon a textured surface.

2. An abstract image created by an unusual or unorthodox viewpoint.

3. An abstract created by blurred or unfocused colour.

4. An abstract in monochrome, showing good contrast and detail.

5. An abstract image that shows a repeating pattern.

6. An abstract image that shows a sense of depth – existing (real), implied or constructed.

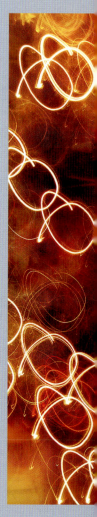

Exercise 4
Abstract
images

← ↑

Title: Abstract images

Source/Photographer:
Jeremy Webb

You don't have to travel too far before abstract images start to reveal themselves. All of the above images were created within a variety of domestic environments and were the result of observing how light, exposure time, viewpoint and proximity can all combine to produce stunning imagery.

5
Movement and flow

Behind many great compositions lies a solid structure of design that acts like an invisible blueprint upon which all the visible matter of the photographic content appears to rest. Much of what often passes for compositional 'genius' in the art world may in fact be simply the result of a genuine gift of artistic instinct; perhaps developed unknowingly through an immersion or interest in visual art initiated at an early age.

We are all, however, able to draw on the power of composition and design skills, and this is necessary in order to support the creation of original and engaging photography. Visual artists of all kinds continually make use of many of the design tools and techniques that provide the means by which the very static nature of the single image can be offset, or at least partly overcome, by directing the gaze of the viewer within the image and conveying a sensation of movement or flow.

Title: Uncertainty

Source/Photographer:
Ansen Seale

The photographer's imaginative use of slitscan photography allows strange collisions of movement and time to take place in a process where 'unmoving objects are blurred and moving bodies are rendered clearly. This image has resulted in an unusual repetition of a single figure, with each of the four elements or stages being marginally different from the next.

The use of directional forces allows the photographer to steer the eye of the viewer towards particular elements in an image – maybe in a particular order or simply to guide the viewer around the image in a journey that will make the most sense to him or her.

This process is simply not achievable when faced with a fast-moving subject matter or in situations where time and subject motion are beyond our control. However, it's possible to maintain peak interest in an image by carefully observing line (both real and imagined) and direction within the frame. Being able to produce compositions that are capable of directing the eyes' movement in this way is a valuable skill for any photographer.

Lines

The use of a line quite naturally demands that our eye follows it. We're simply conditioned that way. Exploiting this knowledge allows photographers to place elements at particular points towards the beginning and end of those lines. Thus, the eye is encouraged to travel from one end to the other and explore points or areas of interest in between.

When we talk about lines in photography, there are two types to consider: real lines and optical lines. Real lines are distinct design elements within the image, while optical lines are not actually visible – they are lines of eye movement that connect and link different elements within the same frame.

Diagonal (optical) lines can work in several ways. They create dynamic and powerful 'lines of force' if created from bottom left to top right. However, they have less of an impact when they run from top left to bottom right. It's also worth remembering that diagonal lines that run from right to left often run counter to the brain's conditioning for left–right movement.

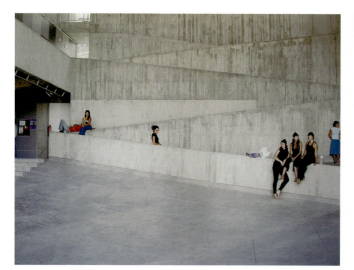

Title: Drama school, 2006

Source/Photographer:
Hannah Starkey

Making deliberate use of the diagonal lines that zigzag across the scene, the left-to-right horizontal movement in the image is disrupted by human figures interrupting the linear patterns created.

Curves

From a design point of view, a curved line is at its most powerful when set against straight lines. It acts as a contrast to the more mundane and uniform straight line by introducing an element of change, softness or unpredictability that can be very powerful if placed appropriately and sensitively within the composition.

More generally, curves are traditionally associated with the feminine form and features; they are found in natural forms such as rolling landscapes or rounded pebbles. The appearance of a curve or curves can signify associations with water, nature, spirituality and a certain calmness, which offsets the more rigid and inflexible straight line.

Title: Grey pavement

Source/Photographer:
Jeremy Webb

Interesting compositions can be observed and created from almost anything – even the pavement beneath your feet. A strong curved form sweeps through the linear grid of paving stones, and further pattern is revealed in post-capture image editing to bring out the pattern and texture of the pavement slabs.

Student photographer Tomasz Tylicki took a bold approach to a coursework assignment to photograph aspects of the seafront in Portsmouth, UK.

The exterior shot of the restaurant windows and deck umbrella contains an arrangement of lines, reflections and areas of complex detail that divide up the frame into a range of different spaces and shapes.

The strength of the composition lies in the careful position, distance and viewpoint the photographer adopted for the shot, carefully excluding any unwanted surrounding detail, yet at the same time allowing the complex nature of the lines and forms of the architectural environment to speak for themselves.

The interior image of the seats in front of the bar area relies on a simpler, less complex image of the restaurant seating, where harmonious colours and repeating shapes are the predominant design elements on display.

Case study 5 Lines and shapes

Title: Portsmouth

Source/Photographer:
Tomasz Tylicki

Shooting locations, such as the ones shown, for commercial clients provide creative challenges for many photographers. From a design point of view, it requires the photographer to be very selective in what they include and what they exclude, and to make the most of the available light in order to retain atmosphere and ambience – especially where interiors are concerned.

A great family experience

Photographic images not only allow us to wander and explore freely within our images, but they also keep the audience contained and engaged with the experience. Photographers want the viewer to be engaged long enough so that their message is completely appreciated and understood.

The trouble is, once we become proficient at leading our viewers through our skilful use of optical lines and beautiful sweeping curves, those same lines can take our curious visitor right out of the picture and on to something else. Suddenly, the interest is no longer held and the viewer becomes aware of the space outside the image.

This is often the result of an optical or real line leading us right out of the picture. If this is the case, the scene and its component elements need to be contained. Sometimes, this is possible by placing detail or an interrupting element at the end of the errant line; the line then ceases to become an exit route for our eye. Skilful and sensitive observation of areas of light or shadow can also be used to obscure a line that seems to be heading out of the frame. There are also other means of attaining containment.

Title: On the wall, 1983

Source/Photographer:
Olivia Parker

The very edges of a piece of sheet film have created an instant border for this image that neatly contains the image content and prevents the whites and the lighter tones from bleeding and merging onto a white page.

**Title: 'Big' Joe Thomas –
offensive tackle
Cleveland Browns**

Source/Photographer:
Peter Read Miller

The border created by the sheet film edges creates the simple means by which the size and 'larger-than-life' presence of the subject can be held inside the image border. The subject fills the frame and space, and leaves nothing in the way of background to distract the viewer.

Use of borders

Borders are a contentious issue among many photographers. A few purists still argue against the essentially manufactured construction of a border. They prefer a less mediated treatment of the image, allowing the picture to breathe in its own space without restrictive or artificially introduced graphic treatments.

All photographs have a border – the inevitable boundary or the edge between image and non-image. It's how we treat this edge that is of most importance to the design-conscious photographer.

For instance, thick borders can be too clumsy. Too thick and the border starts to intrude on the image; it could dominate and overwhelm. Thick borders can be too clumsy. Many photographers prefer to use a thin key line that denotes, in a much more subtle way, the edge of the image. Key lines contain the image elements, but never allow the discreet border to dominate or reduce the power of the image.

The use of borders is certainly something that photographers should consider in the presentation of their own work. For many occasions such decisions in the commercial world may be taken out of their hands by picture editors and designers, who have aesthetic decisions to make concerning layouts and whole page designs.

Some photographers who exhibit their work at exhibitions prefer to block mount their images by adhering their images to flat surfaces. The thickness of these surfaces allows the image to extend outwards and away from the gallery wall, appearing to have no border or boundary as such, except for the image edge that is now defined by the space and thickness of the presentation surface rather than line.

Frames within frames

If one frame can be said to contain an image, would two frames emphasize the subject further? Framing exists to select and isolate a fragment of the world and keep it held within an enclosed space. Every image, in a sense, is framed simply because there is a definite and tangible edge to the space that contains the image content. Putting a frame within a frame allows the photographer to create another picture within a wider picture.

The frame shape is obviously determined by the subject – it need not be rectangular – it could be circular, or a series of shapes (for example, portholes on the side of a cruise liner, or a landscape divided into smaller views by several windows on the side of a train carriage).

As a compositional device, framing allows the photographer to potentially tell several stories at once; it can offer separate but related views of the same subject, or multiple points of view. It can also be very effective in providing a sense of depth to a scene, especially if the framing occurs in the foreground and divides the background into smaller portions.

Used with care and judgement, frames within frames increase our understanding and appreciation of a subject, but applied with little thought or care given to the overall composition, the use of a poorly chosen framing device can make imagery appear contrived and self-consciously constructed.

Framing devices can be as simple or as complex as you like:

A single rectangular frame – ordered in a neat fashion, with bottom and top frame edges of the inner frame creating a parallel distance between those of the outer frame.

Disordered – allows a less static arrangement without parallels, making a more dynamic composition with diagonal lines, though still structured around straight lines.

Concerned with several different shapes – could be a circular frame within a traditional rectangular outer frame.

Intersecting or overlapping – contains one or more inner frame shapes, hence creating further geometry.

Title: Glove 2 duo

Source/Photographer:
Jeremy Webb

The use of a discarded picture frame allowed the staging of a series of still life studies where ordinary gardening gloves were presented and linked by the use of this frame within a frame.

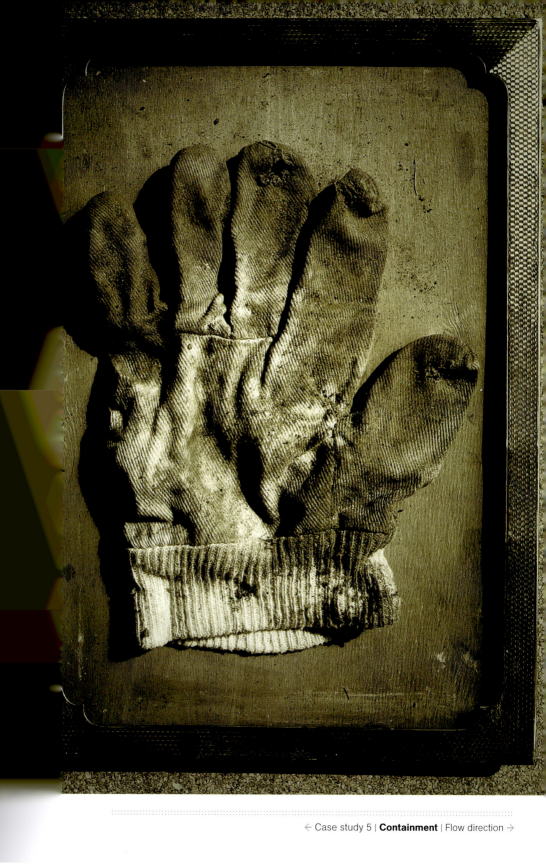

The skilful use of leading lines and directional forces within an image, are fundamental to the degree with which we feel engaged by that image. Without doubt, adherence to this principle is practically impossible when faced with photographic situations where simply getting the shot is the aim, and the aesthetics can be dealt with later.

Being mindful of the power of these optical and real lines to direct our gaze makes it easier to feed the design instinct. This can lead us to create powerful and imaginative compositions in the most difficult and unexpected circumstances.

Flow direction allows our gaze to be steered in a particular fashion through the skilful use of line and curve; it enables us to piece together the various design elements provided by the content of the image.

Human eye preference for left-to-right motion

As we've already seen, this is related to the recognised and established patterns of eye movement. However, the theory falls apart somewhat when applied universally. For example, the decoding of language, signs and symbols in some cultures happens with the eye being trained to travel in the opposite direction.

However, even when faced with an empty rectangle in landscape format, the eye tends to anchor immediately to the top left corner, then zigzag downwards in a left-to-right motion in a seemingly futile attempt to read what isn't there.

This knowledge is not much use in and of itself, but for photographers it has very real implications as this has an impact on composition. Elements arranged within the usual pattern of left-to-right eye movement will meet with little visual discomfort or obstruction. Compositions arranged in the opposite direction can sometimes appear odd, and yet we're not quite sure why.

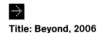

Title: Beyond, 2006

Source/Photographer:
Mona Kuhn

Mona Kuhn's beautiful images conveys a softness and intrigue achieved in part by her use of exposure and depth of field, and also by the skill with which she composes her images. Here, she guides the gaze from the top left of the frame to the furthest point at bottom right in this beautifully constructed image.

Flow direction allows our gaze to be steered in a particular fashion through the skilful use of line and curve.

Horizontal

The use of horizontal lines to influence flow direction can be forcefully employed when using the landscape format since it has the potential to travel the distance between the widest points within the frame.

In such a way, a horizon line becomes a dominant design element that resonates with our primeval urge to scan the horizon line for a predator threat or the returning tribe. We explore the points adjacent to the horizon and will tend to begin our journey to the left and finish on the right, unless interrupting elements or dominant features are placed towards the right-hand side of the centre, which encourage us to start here and work towards the left.

Horizontal lines used within a portrait format image can be used quite effectively to disrupt the expectation that long, wide lines should be placed within the longer, wider proportions of the landscape format.

Wide-angle lenses often distort a straight line so that long empty horizons photographed at an angle show a large degree of barrel distortion. For some photographers, the ability of these lenses to distort the arrow-straight lines of architecture, for example, hold a creative appeal. But for others (particularly those in commercial photography), the effect is a professional nuisance and must be controlled. This can be done by using either a monorail camera or post-capture digital image processing.

Title: Dave Grohl

Source/Photographer:
Neil Gavin

Bright overhead sunlight has created subtle shadows on the subject's face, which appear to drop vertically from the fringe, echoing the stronger vertical lines in the background. Taking the portrait from below the subject increases the vertical strength of the image, and the use of the colour blue throughout further strengthens its appeal.

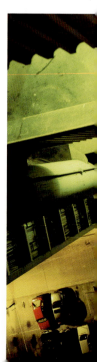

Vertical

The use of vertical lines to direct the flow of movement and gaze is most often seen in portrait format images where their length and dynamic movement can be contained easily. But again, interesting subversions can be created by using the wider landscape format viewfinder to capture vertical lines. This is often exploited by photographers who understand that interest can be generated by switching between different formats.

The photographer has the power to turn any line in any orientation. Photographers who are able to switch their mindset between observing the subject itself and viewing the subject as design elements of form and line have an advantage over those whose vision extends only towards observing the subject as subject only.

Diagonal

Images that contain no vertical or horizontal lines can appeal to the eye since comparisons are subconsciously made between the dominant elements of the design and an 'index' of order (provided by the right-angled vertical and horizontal lines of the frame) that contains them.

Diagonal lines, therefore, become dynamic and powerful forces that are able to create many interesting forms and intersecting patterns of line. Diamond and triangular shapes become strong design structures with which to build around when placed within the solid and reliably dependable rectangular frame. Do not go out and shoot endless diagonal lines in the mistaken belief that this will somehow make your photography instantly more appealing. The application of this aspect of design is most useful when 'reading' images generally; absorb the knowledge into your appreciation of the visual lexicon.

Title: Vertiginous exhilaration

Source/Photographer:
Rut Blees Luxemburg

The sense of urban danger and discomfort in this image is created in part by the daring viewpoint adopted, but strengthened further by the diagonal lines that provide more dynamic lines of force within a rectangular frame.

Choose a building in your neighbourhood that you are familiar with. It may be something you pass by each day: a rundown, abandoned house, a church, a skyscraper or a corner shop – any place that holds your interest or engages your curiosity.

Spend around half an hour observing its qualities, its physical properties and how the light falls on its different areas. Don't take any photographs yet, just observe your subject with an open mind and with your senses tuned to its construction and appearance. Then ask yourself some questions: Does it contain textures, patterns or colours that intrigue you? How does it make you feel? What role does this building hold in the immediate environment or community? What purpose does it or did it serve?

If it is a building or property that you can legally and safely enter inside, what do you find there? Bear in mind that you may have to gain permission if the building is in public use or on private land. Can you capture the spirit of the place by focusing on a detail that tells a bigger story? How can you best use the light available to you?

When you feel you are ready, determine an approach towards photographing your subject. Try to incorporate some of the design elements we've explored so far. In particular, pay attention to line, colour, curves, frames within frames, points of interest, abstracts and depth of field. Take 20 shots only and edit your series down to six images that create a unified and engaging set of images.

Exercise 5
Observation

Title: Exercise in observation

Source/Photographer:
Jeremy Webb

Unlike film photography, digital capture means we can take endless images of a subject without having to worry about cost, or using up a limited number of frames. Because of this, many creative digital photographers have had to become very skilful at editing their own work rigorously, which often means limiting the number of images you shoot or having to take some very tough decisions later on.

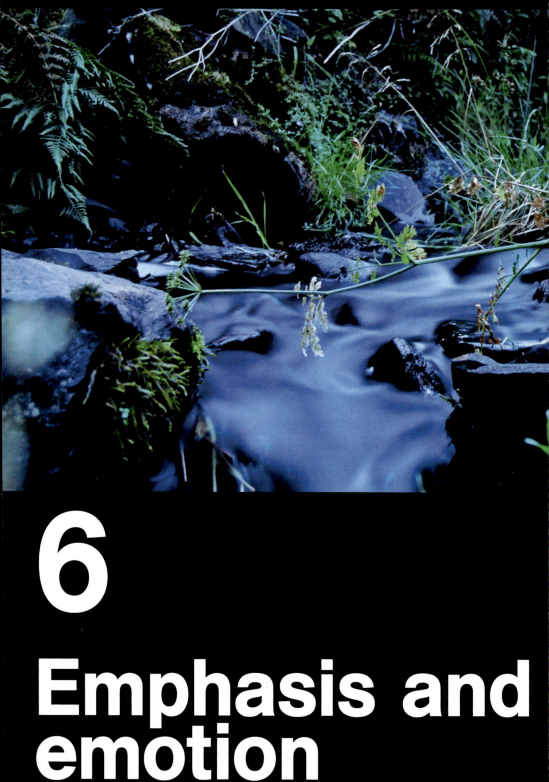

6
Emphasis and emotion

Photography has the power to influence us on a deep level; it affects our emotional lives, attitudes and our behaviour in ways that often surprise. At its best, it's this aspect of the medium that persuades us to donate money to an appeal; buy products we don't really need; visit exotic locations on the other side of the world; or pay a small fortune for a print to display proudly on the wall.

The careful and creative construction of an image plays a huge part in transporting the vision of one photographer to a wider audience, but this is not learned by rote nor from a checklist of aesthetic dos and don'ts that magically guarantee success. More often than not, the nuts and bolts of good composition and the application of good technique are intuitive and deeply rooted in the photographer.

To give emphasis to a particular item in an image is to promote interest in a particular subject at the expense of something else. This generates powerful effects on our reading of an image and our ability to take from it the meaning that was intended by the photographer.

This section of the book looks at how we can push design principles a little bit further, and how simple photographic techniques can alter these elements in order to maximize emphasis and create emotional impact in our images.

Title: Night stream 4

Source/Photographer:
Jeremy Webb

Where tripods become impractical, the landscape often provides a solution. This image was taken by supporting the camera on a discarded wooden plank that allowed the camera to be lowered and positioned at a spot almost level with the steadily flowing stream. An exposure of eight seconds recorded both the deep blue cast of the evening sky and the motion of the water rendered smooth by the long time exposure.

The point of interest (POI) anchors the viewer within the image. It is usually a principal shape or subject around which the rest of the image information is secondary – a recognizable face turning to look back in the crowd, for example, or a bare tree picked out easily along the flat horizon of a desolate landscape.

Many traditionalists find it hard to shake off rigid rules and received wisdom, and consider the absence of a POI as a weakness. It is hard to argue against this, but it is still possible to create innovative and engaging photography without a POI in the traditional sense. Abstract imagery is one particular field where the image must still convey a persuasive intent and meaning even if it has no obvious POI. Many of the best abstract images simply draw us into a 'landscape of the mind' to deliberately disorientate us; our senses can wander freely without being directed and we are content being lost.

Photographers have a range of design principles at their fingertips, all of which were explored in the earlier chapters. These emphasise or subjugate elements of an image so that a POI can be clearly expressed through the structure of the work. Leading lines, areas of focus/de-focus, colour, and so on, can all be manipulated so that a point of interest can emerge as the principal source of curiosity for an image.

Secondary points of interest

Too many POIs can dilute the ability of an image to communicate its primary theme or subject effectively. A secondary POI can, however, be useful in leading the eye to explore the frame in full. This forces the eye to switch between points and make sense of the configuration of elements and the space used.

Many photographers still work with the theory that primary and secondary POIs should always be applied with the rule of thirds in mind, and placed at the intersections of the grid that divides the rectangular frame into nine sections.

The rule of thirds

Many photographers have quite rightly become very sceptical about the stifling and omnipresent rule of thirds. They claim that its overuse now creates images every bit as mundane and formulaic as the subject-centred images that the application of the rule of thirds tried to improve upon.

In practice, many of the so-called 'rules' of photography are still best treated as part of a photographer's 'armoury of possibilities' rather than applied in every instance regardless of their suitability.

Title: Jennifer and kite, Austin, Texas

Source/Photographer:
Sandy Carson

Simple compositional technique need not be a complex or intimidating thing. Here, the eye takes on a simple journey that starts at the feet, moves up and through the arm and eventually alights on the kite in the sky.

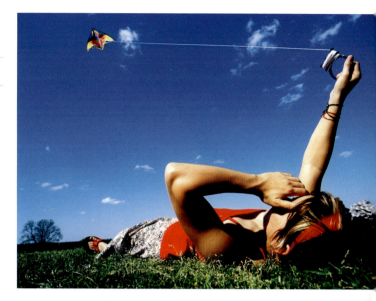

Placement of the point

Some photographers take a very playful approach to POIs almost as a way of challenging rules and the way they can stifle experimentation or innovation. Guy Bourdin is one such photographer who often created lopsided arrangements in his fashion images where the POI was pushed right up against one side of the picture without anything to balance the 'dead' space on the other side.

Many photographers and artists will tell you that POIs should be placed at the intersecting points of a rule of thirds grid. This, it is claimed, places POIs in harmonious positions within the frame and prevents subject matter ending up in dull central areas within the image.

Size of the point

The size of the POI can be of critical importance to the degree with which the image as a whole succeeds or fails. It's not so much the size of the subject we wish to emphasize, but more its size in relation to the rest of the subject matter in the image. A tiny pinprick of light in a dark landscape may be small in every respect, but it will have huge significance if its presence signifies 'rescue' or 'life'.

The change in size of a POI in relation to its surroundings can be affected by the lens chosen. Wide-angle lenses will exaggerate the difference between near and far distance; telephoto lenses will diminish the difference between them. In this way, photographers such as Bill Brandt created stunning wide-angle monochrome images of nudes and landscapes where ordinary perceptions of scale and proportion were stretched like never before.

The use of a single colour

Constructing an image with a single, dominant colour requires care and judgement in order for the right effect to be achieved. At a very simple level, a single tomato positioned over a monochromatic background, for example, will immediately stand out and appear to leap forward.

Single colours in the design of an image work best when their purpose and intention are clear. If colour is not the primary reason for the image, then it may be in competition with (and draw power from) the main subject or POI, which may also lead to confusion over the real intention or purpose of the image.

The visual effect of a single colour as a POI is often made more effective by its placement or positioning within an image. Proportion and a keen sense of composition are often the balancing factors that apply most strongly to creative decisions over the degree to which a single colour is used.

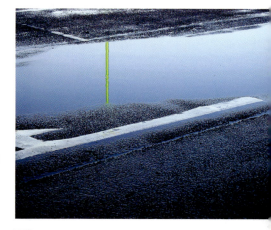

Title: Car park detail

Source/Photographer:
Jeremy Webb

A single spot colour amidst a wealth of cool blues achieves a powerful POI in this empty car park.

UNITED COLORS
OF BENETTON.

Title: House door ajar

Source/Photographer:
Jeremy Webb

Sometimes the expectation of some event or moment of significance holds more appeal than the event itself. This image represents the simple appeal of standing in front of a scene where both photographer and audience are on the threshold of opening the door into a room bathed in golden sunlight.

Title: Newborn baby

Source/Photographer:
Oliviero Toscani

Simplicity is key to the successful transmission of ideas and concepts in photography, and this is no more so than in the field of advertising. Benetton made a series of very stark (and sometimes politically controversial) advertisements to strengthen brand awareness.

Simplicity and complexity

A single POI can be most clearly conveyed when used within a simple image. A background may need to be restful or quiet in order to allow the POI to stand out. A plain sky or uniform area of tone obviously offers little or no pattern, no competing shapes or forms, but it allows the POI to stand out by simply offering nothing to threaten its prominence.

On the other hand, complex images can also offer great visual value by allowing the imagination a more active role in reading an image with multiple points of interest. Such compositions encourage the audience to compare different areas of the image, to make links and connections, or to simply enjoy the opportunity to wander freely around an image that may constantly throw up surprises.

There are two well-known photographic portraits that demonstrate the design differences between simplicity and complexity. Both portraits feature the same subject, Igor Stravinsky, in a black-and-white portrait. The first portrait is by Arnold Newman, taken in 1946. It's a stark, graphic, studio-shot image – incredibly bold and of its time, unique in terms of its composition and simplicity.

Compare this image wit h the more intimate and domestic portrait of Stravinsky taken by Henri Cartier-Bresson in 1967. Stravinksy is now an old man reflecting on life at home. In this image, the great composer seems almost disengaged, allowing us to take a good long look around the bookshelves and busy background of his home. Here, we see the work of two photographers, two unique approaches, and two very different outcomes.

The use of focusing to separate a subject in sharp focus from a background that is unfocused is almost as old as photography itself. To begin with, areas of sharpness were simply a product of the early cameras themselves where depth of field and sharpness were dictated to the photographer by the rudimentary nature of the camera and lens.

Over time, focusing and depth of field became more controllable and photographers began to experiment with the means with which the appearance of depth could be achieved by the eye – comparing a subject in sharp focus against an area of unfocused background or foreground.

The use of focusing to direct our gaze becomes a very powerful way to give emphasis to a subject – it forces the eye to alight with certainty on something sharp and detailed. Photographers who make good creative use of focusing and depth of field are often able to skilfully direct the way we look at their images, and allow us to glimpse their world as they saw it.

Use of lens aperture

Without a doubt, the most useful aspect of photographic technique to acquire is the relationship between lens aperture (or f number) and depth of field (the amount of sharp focus within an image).

Wide or large lens apertures of f2 or f3.5 behave like the pupil of the eye in a darkened room – they remain large to 'drink in' the light required. These lens apertures give the smallest depth of field, and so are useful if you want focus to fall on a single subject, keeping the remaining foreground and/or background detail out of focus.

Small lens apertures of f16 or f22 behave like the pupil of the eye in bright sunlight, closing down to a small hole in order to cope with the brightness of the sun. These lens apertures give the most depth of field, so are most useful if you want good overall sharpness throughout your image, from near foreground right through to far background.

Aperture control, for any photographer, is one of the simplest and most effective methods of applying emphasis; it influences the gaze of the viewer or simply expresses your intention clearly.

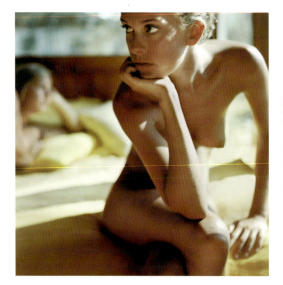

Title: Fatale, 2006

Source/Photographer:
Mona Kuhn

The use of a wide aperture creates a very narrow depth of field (area of focus).

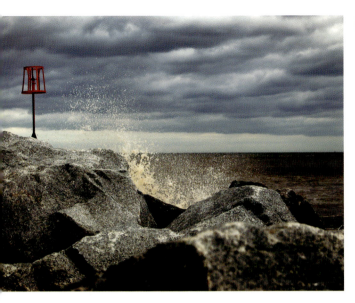

Title: Caister beacon

Source/Photographer:
Jeremy Webb

The use of a de-focused foreground
helps to create a sense of depth as
if peering over the foreground rocks
into the distance.

Use of focal length

Creative photographers rarely stick to just one lens. While many opt for the convenience of a single lens that ranges from wide angle through to standard, to short telephoto, some photographers prefer fixed focal length lenses due to their superior optical quality. Whatever your choice, the lens you use affects the degree of sharpness and depth of field available to you.

In general terms, depending on your lens choice and depth of field, what will be and won't be in focus, will work (very roughly) along these lines:

A standard lens will provide an average depth of field in much the same way as was described in the previous section.

A wide-angle lens will provide a better than average depth of field: more will be in focus at the same lens aperture than is used on the standard lens.

A telephoto lens will provide a less than average depth of field, so that the plane of focus will be small, again still using the same aperture, making good focusing critically important.

Of course, the minute you change your lens focal length the scale and proportions of the scene will change. If you switch to wide angle, for example, you may have to move nearer to the subject; if using a telephoto, you may have to move farther away from the scene or subject in order to capture what you require with your standard lens.

It's very rare that we are ever in a position to study just one thing on its own, devoid of all context or environment. Most of our visual experiences rely on being able to make comparisons and contrasts between one thing and another, deriving pleasure or displeasure from the inter-relationships between objects.

In photography, juxtaposition is the placement of unrelated elements or objects within a frame which then creates an unusual, humorous, or thought-provoking effect on the viewer.

Subject and environment

Melting ice cream cone discovered on the red velvet bedspread of a luxurious hotel bedroom might usefully illustrate how juxtapositions work. The ordinary is presented in a completely alien environment, providing us with an unnatural but interesting scene, which may lead to numerous questions: How did the ice cream get there? Was it put there deliberately? If so, why? Does it belong to a child? Where is that child? How long has it been there? Is this a staged scenario? Was this scene manufactured for the purposes of the photograph?

The key to the torrent of questions arising from this scene is the contrast delivered by the unusual relationship between the primary elements of the juxtaposition. Shoot a melting ice cream on an urban grey pavement and the response is likely to be, 'Ah! What a shame, some poor child has dropped their ice cream' – and that may be the end of that. Juxtapositions enjoy a warm reception with audiences who appreciate the surreal, and who realise that one of the most powerful effects that art can have on all of us is the recognition that questions are far more interesting than answers.

Juxtaposition is a very potent form of creative approach that is well suited to the medium of photography.

Title: Connections #4

Source/Photographer:
Rune Guneriussen

Juxtapositions often allow us to explore an absurd idea for the sheer joy of creating something nonsensical and unreal while at the same time exploiting our sense of the photographic truth of a situation. We know it has been staged, but it still tempts our imaginations to accept it as somehow 'found' and unmediated.

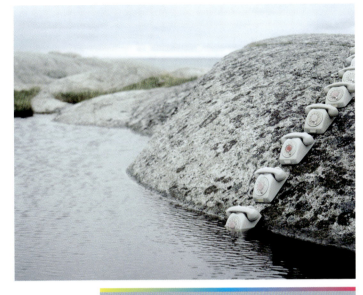

'Forced' relationships

Images that force us to buy into their contrived relationships have a rich tradition in photography. The works of the Dadaists, Man Ray, German Expressionists and even the more recent album cover art of the 70s from Hipgnosis and Storm Thorgerson all show juxtaposition at their heart. Juxtaposition is a very potent form of creative approach that is well suited to the medium of photography.

The are different types of juxtaposition:

· Colour juxtaposition – where clashing or jarring effects are created by the proximity of two clashing colours.

· Size juxtaposition – take, for example, the elephant and the mouse.

· Shape juxtaposition – where contrasting shapes are brought together, for example, a grapefruit on a square plate.

These images were created with juxtaposition in mind. The idea was to combine elements of considerable ugliness and low value with something intended to contain or present something of great value and beauty.

Juxtaposition examines the relationship between different subjects through the human desire to compare and contrast. At its best, it throws up uncomfortable or hard-hitting truths, as well as moments of great beauty or insight.

Juxtapositions require us to enter a strange place that sits uneasily between the real and the unreal. In order to make sense of an image we have to accept that what was there, was there (whether it was or not), and this enables us to manufacture a relationship of sorts between two completely different things, united somehow in one unusual image.

Title: Examples of juxtaposition

Source/Photographer:
Jeremy Webb

Many photographers set out to create juxtapositional images, but they can be found in real-life situations literally a few feet away from where you are now. By being aware of their presence in ordinary life, situations like these will appear out of nowhere.

Case study 6
Juxtaposition

An image that shows incongruity is one that prompts the question: What on earth is that doing there? It generates genuine surprise by putting together the familiar with the unfamiliar in a way that seems absurd or impossible.

It has much in common with juxtaposition, but there is a distinct difference. While the incongruous can be incorporated as part of a juxtaposition, the incongruous is most usually seen as a single element at odds with its environment; it is not an unconventional relationship between two elements. It is something that sticks out like a sore thumb – unsuited to its environment, and disharmonious with the space it occupies.

The incongruous may provoke surprise, laughter, shock or any number of reactions – this is what gives it power and influence.

Scale

Subjects that are larger or smaller than they should be are incongruous when placed or photographed within a normal setting.

This is one sure way of getting something noticed. The absurdity of the situation is what grabs the viewer's attention, and once hooked, they study the scene to assess whether the odd arrangement is real or fake. Advertising photography plays with scale or size incongruity continuously because its effect on perception is immediate and powerful. A number of advertisements in film and print media have featured incongruities such as ordinary people in a landscape full of giant toilet rolls (or is it little people in a landscape full of ordinary toilet rolls?).

As creative concepts go, they may seem hackneyed and unoriginal, but they are certainly effective in their ability to grab our attention and effectiveness (measured by results) always overrides creativity in an industry fuelled by big bucks and big expectations.

Incongruous

An item is described as being incongruous if it is not in harmony or in keeping with its surroundings or environment.

The incongruous may provoke surprise, laughter, shock or any number of reactions – this is what gives it power and influence.

Subject

A subject unsuited to its surroundings takes us a little closer to the idea of juxtaposition again. A penguin in the arctic is neither incongruous nor juxtaposed since it is seen within its natural environment – no surprise or absurdity arises. The same penguin might appear incongruous if it appears in a zoo enclosure or perhaps on Oxford Street in London. But a cute penguin with a flying helmet and goggles would be a juxtaposition, the non-flying bird having apparently appropriated the symbols of flight.

Subjects that provoke the question 'How did that get there?' or the statement 'That just doesn't belong there' are questioning the relationship of unsuitability between a subject and its surroundings.

Title: Nic Chagall 02

Source/Photographer:
Nikolaj Georgiew

The addition of incongruous elements can add an element of the unreal to your images.

It's often said of news photography that a single frame can convey more emotional power than the same subject conveyed by moving film. All the iconic images of the last century – from the troops landing on D-Day, to the shooting of JFK, to the screams of a small naked Vietnamese girl burning with napalm – have been transported to our lives via the medium of still photography. Newsreel footage can elucidate, explain and add powerful interpretations of world events, but it could be argued that still photography of the very best kind distils to a single moment the significance and power of a particular situation or event.

Photography has the power to validate us and confirm our humanity. It makes us recognise and reflect on what it is to be human. The components of design lie at the heart of photography's ability to affect our emotional lives deeply. Even on a superficial level, the calming effect of pastel colours, or the delicate convergence of lines and shadows can transform our imaginations and allow our emotional lives the space within which to expand.

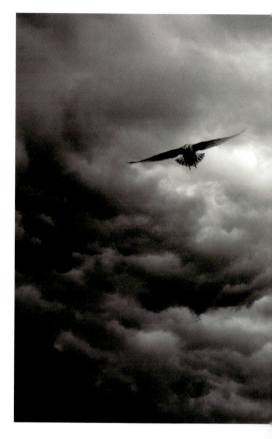

Title: Tension

Source/Photographer:
Jeremy Webb

In a spirit of advertising simplicity, this image was created to depict the inevitable before it actually happens.

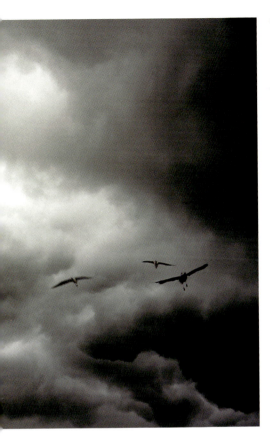

Title: Gulls descending

Source/Photographer:
Jeremy Webb

Although the original cloudscape
image retained more cyan and blue,
a black-and-white treatment gives the
image a much more oppressive feel
evocative of thunder or the threat of a
heavy rainstorm.

Tension and unease

Images can evoke tension and unease when
the viewer is given certain knowledge that
something unpleasant is about to happen.
The image content is arranged or captured
so that the story is set up and the viewer
fills the gaps with his or her imagination.

Sometimes, the use of tension to create an
unnerving visual experience can unsettle
us but there is still no good reason why we
shouldn't be a little uncomfortable every
now and then. The skill lies in taking your
audience with you, not letting them turn away
feeling disturbed or that you've crossed a line.

How to create tension in your images:

Use compositional imbalance to convey
lack of control or a sense of unsteadiness.

Incorporate colour combinations that clash
or jar to induce a sense of nausea.

Feature dark shadows with unseen detail
lurking in the background.

Use unconventional cropping or framing to
create a feeling of claustrophobia.

Take advantage of lighting to make
subjects seem foreign or unfamiliar,
adding a sense of menace or danger.

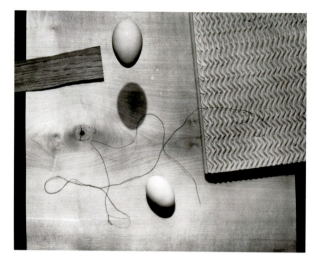

Title: Stilleben mit schwebendem Ei 1930 (ca)

Source/Photographer:
Walter Peterhans

Every element in this carefully balanced still life is in its place for a reason. The carefully designed structure behind this image shows the importance of balance between simplicity and complexity and between showing too little or too much.

Harmony and disharmony

For an image to be considered harmonious, it must contain design elements that complement each other and blend well together. This may be seen in the form of colours, a pattern created by the careful capture of light, or the carefully crafted composition of lines and shapes used in a still life.

Disharmony is most often created by an imbalance present in the image – usually arrived at through inappropriate or poorly judged arrangement of design elements.

Balance and imbalance

Balance is likely to depend upon the positioning and distribution of tone within an image. An image may be considered imbalanced as it will appear top-heavy if dark tones appear as shapes, or large areas are dominant in one part of the image. It may even irritate the viewer due to the absence of a counterweight to even things up.

This is not to say, however, that every image must abide by the rules of balance in order to be effective. Many photographs are visually successful, in spite of an imbalance in the composition. Other factors such as the impact of the subject, use of colour and simplicity may compensate for the imbalance.

One of the best ways to assess an image for its balance is to view it in a mirror, a technique used by Leonardo Da Vinci. This allows for a completely fresh view on the image, enabling the photographer to see how the composition works, where the spaces are, and how the image design structure works as a whole – all from a slightly different point of view.

Alternatively, you can squint through half-closed eyes or turn the image upside down. All these techniques are extra design tools that allow you to reconfigure the image structure temporarily.

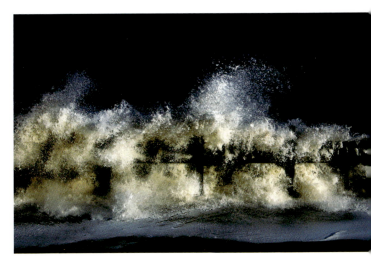

Title: Breakwater smash

Source/Photographer:
Jeremy Webb

Sometimes, certain subjects demand a more impressionistic approach to powerfully convey the mood of the scene. It is not essential to reveal every tiny detail in a dramatic subject if the full drama of the scene cannot be effectively conveyed in the process.

Movement and stillness

Photography grants us the dual pleasure of being able to record and capture a subject's movement over time; it also enables us to capture a single aspect of time. Many photographers have captured frozen moments with fast shutter speeds and bursts of flash, or the fluid grace of subjects in motion for a more impressionistic image.

The notion of movement and stillness may refer to the way in which the eye can become transfixed by a single point of view, or whether it is free to travel between points bounded by the frame. If an image is constructed in such a way that the eye tends to rest upon a single element, the image may be considered as lacking movement (though not necessarily lacking appeal or impact).

If the image encourages the eye to swing left and right, or up and down, in search of meaning reading of the image content and message, the image may be said to contain movement.

Both types of imagery can have a significant effect on the emotional response of the viewer. Images that show minimal movement can sometimes touch us with a simplicity or purity that resonates deeply when applied with a sympathetic subject. On the other hand, images containing frantic directional lines or sweeping curves that take the eye from one corner of the image to the other can be used with more complex compositions, which may demand more work from the viewer. However, this could be equally rewarding in the end, when applied in the appropriate manner and to the right degree.

Select a room in your house, or if you prefer, in the house of a friend or relative. Carefully choose your position, angle and viewpoint. Observe the subject matter and content of your environment. Plan and produce a series of four images that illustrate any four of the following themes:

· Incongruity	· Juxtaposition	· Sharpness
· Security	· Movement	· Blur
· Claustrophobia	· Stillness	· Darkness
· Tension	· The past	· Light
· Balance	· The present	
· Imbalance	· The future	

The key to this exercise is to take a sideways look at your environment. Rather than focusing your attention on the specific subjects you find, look instead at what they may symbolize or represent.

Try to use framing, distance, depth of field, and exposure in a creative way that will help you to explore your chosen themes in depth.

Once again, the outcome of an exercise like this will depend on how you observe light, create depth, and how you position yourself and the camera. The key to an exercise such as this is to understand that creative and imaginative photography isn't necessarily reliant upon filling your viewfinder with a stunning subject. In other words, it's not what you photograph, but how you photograph something.

Exercise 6
Themes

Title: Examples of themes

Source/Photographer:
Jeremy Webb

Creative and imaginative photography isn't necessarily reliant upon filling your viewfinder with a stunning subject – it's not what you photograph, but how you photograph something.

7
Putting it all together

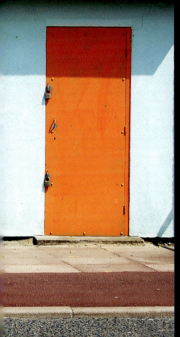

Title: Doors, Gorleston-on-Sea

Source/Photographer:
Jeremy Webb

Colour, shape, line and repetition all feature strongly as design elements behind this image of colourful bathing hut doors. The absence of human figures or reference points also adds another element of interest, allowing the subject to speak for itself with clarity and simplicity.

Any photographer must remember that while design principles can be applied effectively for many picture-taking instances, they are not an off-the-peg magic solution able to transform the mundane into the extraordinary.

Throughout this book, the emphasis has been on introducing a range of options, ideas, or suggestions rather than straight rules to apply with the certainty that their application will inevitably bring success.

One has to keep in mind, though, that the real success that photographers enjoy comes when all that technique, all those theories and all those nuggets of wisdom are put away because they've been absorbed and internalised. The mystery behind the power of photography is distilled to a very simple approach in this quote by John Szarkowski in *The Photographer's Eye*:

'The central act of photography, the act of choosing and eliminating, forces a concentration on the picture edge – the line that separates in from out – and on the shapes that are created by it.'

This section looks at how other areas of your practice can benefit from design if fed carefully into your working methods.

What can we do to really get to grips with a subject and explore it to the full? If you feel passionately about a subject or theme, see if you can approach your subject from a different angle – one that really takes the blinkers off and allows you to experience the subject from different perspectives. Think around the edges of your subject to avoid retreating into the obvious. How have other photographers treated this subject? How does lighting affect your choices of angle, viewpoint and position? What physical features of your subject interest you the most? And how can you emphasize these features most successfully?

This preliminary round of hard questioning is important if you are to avoid falling into the trap of cliché. As photographers, we are all somehow and at some time exposed to the danger of taking the kind of photographs that other photographers take. This is not the route to follow if you want to create fresh, original and exciting photography.

Title: A(part)/together

Source/Photographer:
Katie Shapiro

By presenting a single idea across two separate but related images, Katie Shapiro has successfully conveyed the connection between both subjects and found a metaphor that expresses the title of the series from which this portrait comes.

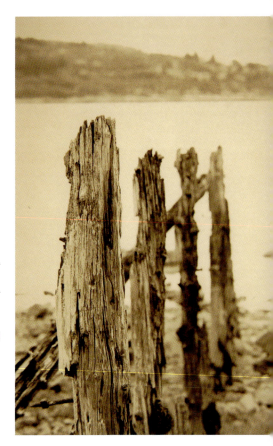

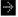

Title: Weathered wood

Source/Photographer:
Jeremy Webb

This digital image was originally a black-and-white toned print, which was then re-photographed in front of a light box. The digital copy has captured some of the softness that this process produces and required very little post-capture image processing.

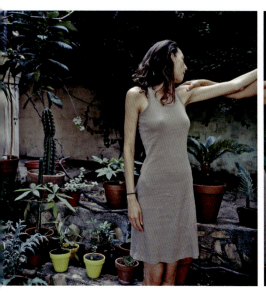

Design principles and presentation of work

Design doesn't start and finish with the production of the print. Many photographers are now finding innovative and exciting ways of presenting their work. This trend has accelerated over the last two decades and photographers such as Wolfgang Tillmans, and many others, have found different ways of showcasing their work.

For some, this involves presenting multiple images in small grid formations, or mounting prints on recycled materials. Photographers have also absorbed some techniques from other art disciplines and use a range of glues, varnishes and other fine art techniques to deliver their visions to a wider audience.

At the other extreme, photographers also have a wealth of digital presentation methods at their disposal – large projection screens, slideshow software, and the option to mix media with digital film, animation and video.

No matter what method you choose, care and a great deal of thought must be given to your presentation. It must be appropriate and suited to the style and nature of your work, and how you intend to communicate your vision.

As we've seen in previous chapters, symbols are signs that represent something. Modern graphic advertising is full of symbols that are easy shortcuts to common concepts. A life belt, for example, can represent help or assistance; a simple graphic of a cup of coffee means 'refreshments available' to weary motorway drivers.

Photography is a versatile medium capable of harnessing the power of symbols to communicate sometimes difficult concepts through imagery short cuts. However, great care should be taken when using signs and symbols because different, perhaps unintended, readings can occur based on the gender, religious or cultural beliefs, and geographical background of the viewer.

The danger of cliché

The danger of cliché lurks around the corner for every creative photographer. Why are we prone to cliché and the endless repetition and recycling of ideas? Some may cling to the comfort of the familiar; others may simply not have the time or the energy to come up with anything original.

Photography sells cliché like no other art form, and no more so than in the commercial world. Stock libraries are full of images that sell concepts: businessmen shaking hands ('closing the deal'); dads cavorting with their beautiful children at the beach ('modern family man'), or elegant ladies sipping white wine at a business lunch ('successful career women').

Recently, there has been a backlash against much of this easy social stereotyping. Many modern image libraries are always looking for fresh ways of meeting the same needs, but with much more dynamic imagery that gives a fresher, more contemporary twist to traditional themes. Successful photographers in this arena are those who are capable of delivering something different – an image that is unambiguous, strong on design, and communicates with economy and confidence.

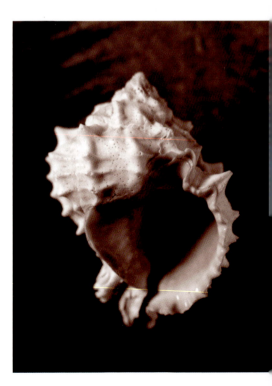

Title: Shell

Source/Photographer:
Jeremy Webb

A shell is symbolic of many things –
nature, a home, protection, refuge and
the sea.

Title: Two men up vines

Source/Photographer:
Jeremy Webb

In recent years, the mass adoption of Photoshop software within the photographic community has had a huge impact on visual culture and the working methods of photographers.

Photography has the power to take us out of the moment.

Gateway to other worlds

Photography has the power to take us out of the moment. Symbolism can speed up this process – it provides photographers with an opportunity to tap into a rich vein of visual clues and access points that link to larger and more complex processes.

Many photographers have attempted to feed symbolism into their work: tunnels and tubes are symbolic of journeys, travelling, birth and death; pyramids can represent hierarchy, aspiration, entombment or mysticism; and circles are symbolic of eternity, completeness and unity.

Some photographers use symbolism as a major driving force for the production of their work. Others simply respond to occasional circumstances when opportunities arise, recognizing on a conscious level the significance of the symbolism before them. There are also times when symbols may not be obvious to the photographer, but they are unlocked and made real by the viewer.

The snapshot aesthetic, or the vernacular, is usually interpreted as an informal approach towards the photographing of the ordinary or the everyday. This form of photography has become very popular in recent years, spawned in part by a generation that has grown up with expectations of immediacy in all things, and the mass adoption of digital technology.

Much of the imagery (but not all) that appears to be informal and grabbed is perfectly genuine and mirrors a resurgent interest in the vernacular as originally practiced by the North American photographers of the 1960s, such as William Eggleston and Stephen Shore. They were spurred on by the influences of pop art, consumerism, artistic democracy and mass media. These photographers turned their cameras towards the mundane aspects of everyday life yet still created some very vibrant and captivating images.

Many of today's 'snapshot art' aficionados are followers of a fashion that has no real recognition of official design aesthetics, preferring to rely on spontaneity as a driving force. Nevertheless, many of the best examples of this genre show a significant degree of strong design at their heart despite their more casual appearance, whether their creators recognize its presence within their work or not. Evidence perhaps that design is a much more internalized force than they might care to admit.

A dip into the world of the vernacular can be a valuable temporary retreat from the norms, principles, rules and aesthetics. It forces photographers to approach the world from a different angle, with a rawness that some may find challenging. The best examples of vernacular snapshots often show at their heart an energy and intensity that are imparted to the viewer by skilful observation of colour, emphasis, pattern or form.

Case study 7
The
vernacular

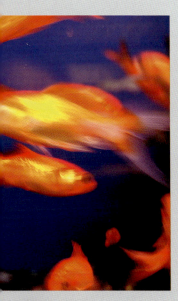

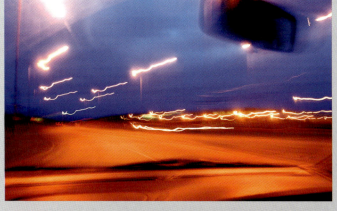

Title: Examples of vernacular imagery

Source/Photographer:
Jeremy Webb

The ease with which lightweight digital technology can be shrunk, placed inside mobile phones or miniature digital cameras, and carried around easily has helped to spawn a resurgence of interest in snapshot photography, as witnessed by the continuing success of websites such as Flickr.

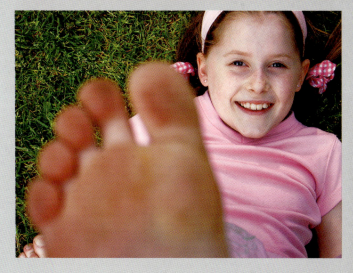

How you convey your ideas and effectively communicate with your audience should largely be driven by your subject. Whether you shoot the subject in colour or black and white, whether you use single images or sets and series, whether you take a dispassionate forensic view at distance or foster a close personal relationship with your subject, your creative strategy should convey your creative concept with clarity.

Your creative strategy should convey your creative concept with clarity.

Title: Coco

Source/Photographer:
Nikolaj Georgiew

The lightness of the woman's skin stands out against the dark blue background providing good foreground/background separation in this beautifully composed image.

Using design principles to overturn expectations

A well-known, two-page advertising campaign for Levi's jeans shot by Nick Knight shows what appears to be the rear view of a tall, long-legged, blonde-haired young woman standing in a confident pose with legs wide apart, and a hand combing through her waist-length hair. It's a deliberately seductive image, typical of the style and technique that advertising and fashion photographers use. Turn the page and the truth is out. The subject is not the young model we all expected it to be, but is actually silver-haired, 79-year-old model Josephine Mann. She smiles knowingly behind a Stetson hat, in the same defiant pose, having made us all feel a little embarrassed at our own daft assumptions.

The appeal of this two-page print advertisement lies in our delight at being conned. Our assumptions were tested and found wanting. The ad itself neatly highlights the kind of shallow judgements we're expected to make while powerfully aligning a product with the notion that unique and individualist people wear the jeans.

Photography used in this way allows us to challenge the way we perceive the world. Even the photographing of abstracts of indeterminate subject matter gives us the chance to view the ordinary in extraordinary ways. It's a compelling strategy to take if you can find the means with which to disrupt our view of the world, whether this be on an everyday mundane level or on a cosmic scale.

Simplicity vs complexity

Some images succeed because they deliver a message so unequivocal and straightforward that there is only one way to read it. Such images are often the result of a very simple design: single point of view, minimal background or a single predominant colour.

It's no surprise that the worlds of print media advertising, editorial, fashion and news journalism depend on a regular supply of images structured around an approach to design simplicity. Simple equals stark. It gets noticed; it is immediate and unambiguous.

Complex images may be constructed from a much wider range of design principles. They may have multiple points of view, competing patterns and forms, perhaps clashing colour palettes, all of which add layers of additional difficulty or impenetrability to an image.

Such images generally appear in contexts where the viewer doesn't have to be grabbed and bludgeoned with the immediacy of the message. They can be found in books and magazines, for example, where readers have time to peruse and deliberate, or art galleries where photographers can explore more complex themes with their work.

As creative photographers, we must try to master a variety of creative approaches and effectively incorporate both simplicity and complexity in our image-making.

Design and conceptual photography

While design principles can be discussed endlessly in terms of their application to many different forms or strands of photography – landscape, commercial, portrait, to name a few – there exists much confusion about the term 'conceptual'. Conceptual photography begins with the idea – the concept. It can communicate a simple message, sometimes a political, social, historical or cultural comment, sometimes a personal joke or irony. The important thing that unites all conceptual photographs is that they have to start out as ideas which then require the use of a range of design principles in order to be delivered.

So what design elements are used in conceptual photography? Anything that allows for the clean and economical delivery of the message. Conceptual photography enjoys a healthy regard for symbolism (see pages 164–165). These symbols are used by conceptual photographers to represent aspects or whole parts of the message contained within the image.

In order to achieve an unambiguous and clear reading of an image, conceptual photography makes use of design simplicity, minimalism and other design ingredients that convey ideas with directness. Some photographers allow or encourage subjective interpretations – enabling individuals to bring their own experiences and backgrounds to an image in order to find their own meanings. Others attempt to create images that supply one, and only one, message that appeals universally.

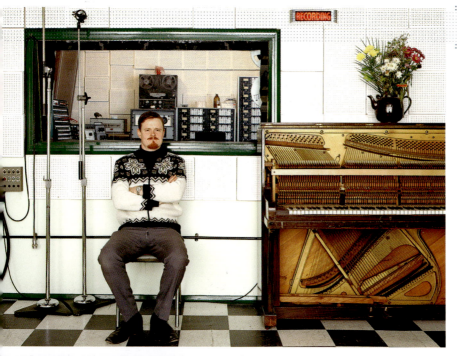

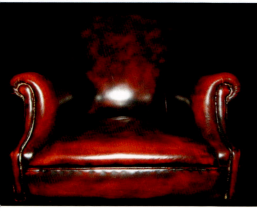

Title: Toe-rag studio

Source/Photographer:
Angus Fraser

An astonishing range of pattern, colour and intricate detail is present within this wonderful image. The work remains well-balanced and every single element (down to the teapot and the small rectangle of the red 'Recording' sign) seems to be rightfully in its place. And yet, because all the image detail is divided up into separate portions, and all the elements are given space to breathe, the image never appears to be too dense or complex.

Title: Leather armchair

Source/Photographer:
Jeremy Webb

Pop-up flashes on digital cameras are a poor substitute for a dedicated flashgun. On this occasion, however, its stark and indiscriminate light managed to render the leather on the chair perfectly. The flash fall-off meant that nothing of the background was illuminated enough to record on the sensor.

Since this is the final exercise in the book, this assignment requires you to produce a variety of creative responses to a single concept or idea. It's designed to encourage lateral thinking, conceptual skills, observational skills, presentation skills and the creative freedom to incorporate a range of design principles in your work. Select a single word from the list below:

· Roll · Bridge

· Sink · Bounce

· Corner · Disturbance

Once you've made your selection, proceed to produce the following:

A conceptual image based on your chosen word.

An image observed and captured from observation.

An image that presents an unusual interpretation or alternative view.

A single presentation of your concept created by a montage or series of six or more smaller images of the same subject.

Exercise 7 Concepts and ideas

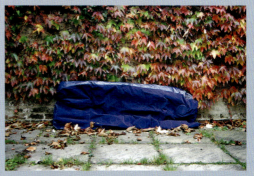
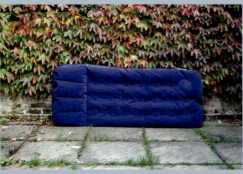

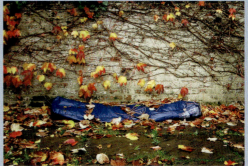
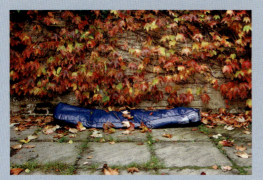

Title: Inflation/deflation series

Source/Photographer:
Jeremy Webb

This simple series emerged from a humorous attempt to produce a visual metaphor for the economic downturn. The collapsing airbed represents a similarly deflating economy against a backdrop of leaves that depict the passage of time.

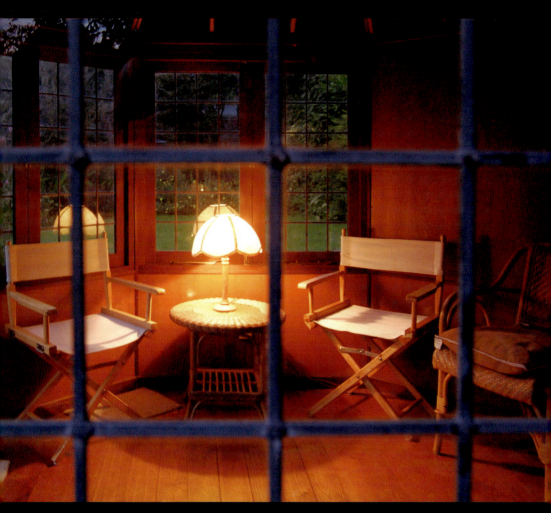

Title: Summerhouse

Source/Photographer:
Jeremy Webb

Blurred foreground detail can add a
sense of depth to an image. In this
case, it offers a 'frames within frames'
layer of cooler blue to invite the viewer
forward towards the warmer glow of
the table lamp.

Conclusion

There's no right way or wrong way to produce photographs – only a selection of choices to make along the way. Adopting a design-aware approach to photography does not limit you to a narrow portfolio of acceptable choices – it opens up a feast of possibility and gives power to both the photographer and the image.

Simplify, emphasize and isolate. Don't let the strength of your image-making be diluted by unnecessary or distracting detail.

Be sure of your intent. Don't allow your work to be driven by equipment or technique. Focus on what fascinates you about your subject. Always question why it is that you are photographing something.

Limit yourself – having the discipline to accept self-imposed restrictions can focus your intent and release creativity and insight.

Avoid following current fashions and trends; move away from the familiar in order to take a more objective view or find fresh inspiration.

Remember that the design structure of an image can communicate with intensity well before any reading of its meaning or intent takes place. This may well provide the basis for an 'unintended stay', which then allows meaning to unfold. Such an opportunity may not arise if the image is constructed with less attention given to its design, at which point, the viewer moves on.

Recognize that the subject in front of your lens may not be the only subject in the image.

Accept your mistakes as part of your learning, but never be afraid to take risks.

And finally...

Love what you do. Wear many different hats and free yourself from negativity. The process by which we become intuitive and fluid with design is a journey that should be enjoyed for its own sake. It will take time to feed into your work, but it soon takes on a life of its own within you.

Photographers often find that although they may continually test the limits and boundaries of their own design awareness, their commitment to the design process simply becomes internalized and fluid, and once you can approach your photography with the confidence that comes from this knowledge, your work can breathe once again, allowing your photography to become liberated, spontaneous and highly creative.

Glossary

Abstract – non-representational; dealing with a way of seeing that extracts value from producing images based around ideas and evocations rather than a descriptive showing of the thing itself.

Analogue – refers to the traditional film capture and process of photographic images.

Aperture – the opening in the lens that controls the amount of light reaching the film (used in conjunction with the shutter speed).

Barrel distortion – a defect of optical lenses in which straight, horizontal or vertical lines appear to be convex curves.

Bounced flash – achieves softer light from a flash gun or flash head by bouncing the flash off a nearby wall, ceiling or white reflector.

Bracketing – method of ensuring correct exposure by taking several additional pictures, usually +1 stop above the given exposure, and -1 stop below the given exposure.

Composition – the artistic arrangement of the subject matter within a photographic image.

Contact sheet – A print made on photographic paper by exposing the paper to light with the negatives in direct contact with the print. These same size "thumbnail" images are used as a basis to establish which images to print, what cropping needs to take place and so on, although some larger format negatives, due to their size, can create their own contact prints without the necessity of an enlarger.

Containment – keeping something held in or contained.

De-focused – allowing some of the image area to remain out of focus.

Depth – the appearance or impression of near and far within a photographic image.

Depth of field – The amount of a picture that will appear sharp in front of and behind the point at which you focus the lens. Large depth of field refers to a large area of the picture being in sharp focus from near foreground to far distance, usually achieved with wide-angle lenses or small apertures of f16, f22 etc. Small depth of field indicates a very narrow band of focus often through the use of wide apertures such as f1.2 or f2.

Directional forces – the organization of visual matter or elements that encourage the viewer to observe the image content following a particular line or direction.

Duotone – popular Adobe Photoshop effect that gives the appearance of hand-toned photographs by using black and another colour ink when working in greyscale mode.

Exposure – results in the combination of lens aperture and shutter speed, which is used to control the intensity of light reaching the film.

Expressionist – artwork that generally responds to and reflects the inner world of emotion, often using distortion or other effects to reflect the idea of an inner reality.

F-stop – indicates the size of the lens aperture. The smaller the number, the wider the aperture, the higher the number, the smaller the aperture.

Flattening – In Photoshop, the process of merging together all layers within the file to return the image again to one, single background image.

Focal length – the distance between the centre of a lens and its focus.

Format – the shape, size and proportions of the image area.

Gaussian blur – used within Photoshop, this creates a softer, de-focussed effect.

Grain – composed of minute metallic silver particles in film that form the visible image when exposed and developed.

Greyscale – Print or transparency consisting of a series of grey tones of regular increasing depth from white to black.

History Palette – Within Photoshop, every time you modify or edit your image, it is recorded as a history state within the History Palette. This chronological recording of events can be used if you want to return to an earlier state within the current work session.

Incongruity – something that is not in harmony with, or is poorly suited to, the environment within which it is placed.

ISO – Initials of the International Standards Organisation – used to indicate the speed or light sensitivity of photographic materials.

JPEG – a type of digital image file that compresses files by up to 75 per cent although some image data can be lost. Usually produces smaller file sizes than PSDs or TIFFs, hence it is easier to send via email or as screen previews.

Juxtapose – to position or place in close proximity with something else producing contrast, surprise or other strong reaction.

Layers Palette – An information palette within the Photoshop interface that provides information on the number and type of layers within a digital image. New layers are automatically created when using the type tool, and when any copy-and-paste work is undertaken.

Monochrome – black and white.

Monotone – a single colour.

Multiple exposure – more than one exposure captured within the same frame or produced within the same image.

Panning – the photographer follows the action in front of him or her by attempting to move the camera at a sympathetic speed to track the subject. The result often renders the subject as sharp or semi-sharp against a blurred background.

Pixellation – the 'blocky' effect that occurs when an image is enlarged to a size where the pixels become obvious.

Pixels – individual picture elements usually (though not exclusively) seen as square blocks that form the basis of all digital images. Most visible at high magnification if the image is said to be of high resolution. More easily visible in low resolution digital images such as those using the jpeg file type.

PSD – stands for Photoshop Document and is the native file format for Photoshop images; most often used for works in progress, or layered images that require many work sessions, or multiple openings and closings of the file.

Raking light – bright light that illuminates across the surface of a subject highlighting its texture or detail.

Resolution – the picture detail, sharpness, or quality of a digital image measured in pixels per inch. The higher the resolution, the higher the quality and detail, and the bigger the file size.

Reticulation – Formation of minute cracks on the surface of an emulsion, usually caused by extreme temperatures during processing. Modern films are normally very resistant to reticulation.

Safelight – Darkroom light of a particular wavelength to which the photographic paper is not sensitive. This allows you to see and handle materials in the darkroom. In the case of black-and-white printing, the appropriate safelight is usually an orange, red or deep green.

Saturation – the strength or intensity of colour.

Shutter speed – The amount of time (usually measured in fractions of a second) for which a camera shutter remains open, permitting light channelled through the lens to fall on the film.

Soft box – a large diffuser placed over a studio flash head to soften the light.

Symbolism – the use of symbolic images or visual metaphors to express ideas, emotions or states of mind.

Telephoto lens – A lens providing a longer focal length than a standard lens, giving a narrow field of view and enabling the photographer to get closer to the subject than a standard lens would allow.

TIFF – a type of high-quality digital image file; stands for Tagged Image File Format and supports up to 24-bit colour per pixel.

TTL – is 'through- the-lens' metering, a method that uses light-sensitive exposure metering cells within the camera body to take readings of the reflected light falling on the subject, exactly as seen by the lens. In automatic cameras, these readings are translated directly into apertures and/or shutter speeds.

Vanishing point – The point where receding parallel lines viewed in perspective appear to converge at a point in the distance.

Viewfinder – the device used on camera that shows the field of view of the lens used.

Vignetting – is the visual effect of the darkening of edges and corners. Can be deliberate or accidental.

Wide-angle lens – A lens that takes in a wide view.

Contemporary photography

Art Photography Now by Susan Bright, pub: Thames & Hudson.

Blink pub. the editors at Phaidon.

How You Look at It: Photography of the 20th Century, Ed: Heinz Liesbrock & Thomas Weski, pub: Thames & Hudson.

Image Makers, Image Takers by Anne-Celine Jaeger, pub: Thames & Hudson.

Public Relations – New British Photography, pub: Cantz.

Creativity/inspiration/ideas

Exploring Colour Photography: A Complete Guide by Robert Hirsch, pub: Lawrence King Publishing Ltd.

Fine Art Photography: Creating Beautiful Images for Sale and Display by Terry Hope, pub: Rotovision.

Innovation/Imagination: 50 Years of Polaroid photography pub. Harry N Abrams.

Looking at Photographs by John Szarkowski, pub: Museum of Modern Art, New York.

Susan Sontag On Photography by Susan Sontag pub: Penguin.

Tao of Photography by Tom Ang, pub: Mitchell Beazley.

The Art of Enhanced Photography by James Luciana and Judith Watts, pub: Mitchell Beazley.

The Impossible Image: Fashion Photography in the Digital Age pub: Phaidon.

The Nature of Still Life: From Fox Talbot to the Present Day Ed: Peter Weiermair, pub: Electa.

The Photographer's Eye (Composition and Design for Better Digital Photos) by Michael Freeman, pub: ILEX.

General/reference

Approaching Photography by Paul Hill, pub: Photographers Institute Press.

Fine Art Photography by Terry Hope pub: Rotovision.

Home Photography by Andrew Sanderson, pub: Argentum.

Innovation/Imagination: 50 Years of Polaroid photography, pub: Harry N Abrams.

Photographic Possibilities (2nd edition) by Robert Hirsch & John Valentino, pub: Focal Press.

Photography as Fine Art (Introduction by Douglas Davis), pub: Thames & Hudson.

Photography: The Key Concepts by David Bate, pub: Berg.

Right Brain, Left Brain Photography by Kathryn Marx, pub: Amphoto.

Susan Sontag on Photography by Susan Sontag, pub: Penguin.

The Abrams Encyclopedia of Photography, Brigitte Gouignon Editor-in-chief, pub: Harry N Abrams.

The Focal Encyclopedia of Photography (4th Ed), Michael R Peres Editor-in-chief, pub: Focal Press.

The Oxford Companion to the Photograph, Ed: Robin Lenman, pub: Oxford University Press.

The Photography Handbook by Terence Wright, pub: Routledge.

What's Missing? Realising Our Photographic Potential, compiled by Eddie Ephraums, pub: Argentum.

Instructional (for film-based photography)

Creative Photo Printmaking by Theresa Airey, pub: Amphoto Books.

Cyanotype: The History, Science and Art of Photographic Printing in Prussiona Blue, by Mike Ware, pub: The Science Museum and The National Museum of Photography, Film and Television.

Photography's Antiquarian Avant Garde – The New Wave in Old Processes by Lyle Rexer, pub: Harry N Abrams.

Silver Gelatin: A User's Guide to Liquid Photographic Emulsions by Martin Reed & Sarah Jones, pub: Working Books Ltd.

Spirits of Salts: A Working Guide to Old Photographic Processes, by Randall Webb & Martin Reed, pub: Argentum.

Sun Prints by Linda McCartney, pub: Ebury Press.

The Darkroom Cookbook (2nd edition) by Stephen G Anchell, pub: Focal Press.

Photographers and projects to explore

Altered Landscapes by John Pfahl, pub: The Friends of Photography in association with the Robert Freidus Gallery.

Brandt: The Photographs of Bill Brandt, pub: Thames & Hudson.

Couples and Loneliness by Nan Goldin, pub: Korinsha Press.

Harry Callahan: The Photographer at Work by Brett Salvesen, pub: Centre for Creative Photography and Yale University Press.

Karl Blossfeldt Photography, pub: Cantz.

Koudelka: Reconnaissance Wales pub: Ffotogallery in association with the Cardiff Bay Arts Trust, The National Museum and Galleries of Wales and Magnum Photos.

Other Edens by Nick Waplington, pub: Aperture.

Philip Lorca diCorcia, pub: The Museum Of Modern Art, New York.

Robert Doisneau: A Photographer's Life, by Peter Hamilton pub: Abbeville Press.

The Americans by Robert Frank, pub: Scalo.

The Democratic Forrest by William Eggleston, pub: Doubleday.

Useful websites (magazines, forums, online publishing and resources)

www.a-n.co.uk
The website of Artists Newsletter – a wealth of information for visual artists – funding, contracts, exhibitions, opportunities and much more.

www.the-aop.org
The Association of Photographers.

www.aperture.org
The Aperture Foundation – photography in all its forms.

www.aphotoeditor.com
An insider's guide to the business of photography.

www.apug.org/forums/home.php
Resources and forum for the analogue photographer.

www.artscouncil.org.uk
Access to grants and funding information.

www.art-support.com
US-based resources for photographers, some international contacts.

www.thebfp.com
The website of the Bureau of Freelance Photographers.

www.bjp-online.com
The website of the British Journal of Photography.

www.theblacksnapper.net/archive
International online photography magazine of mostly documentary and photojournalism.

www.thecolorawards.com
Inspiring photography from this well-established awards for excellence.

www.dayfour.info
Online photography showcase of photographers' personal work.

www.digitaltruth.com
Resources of all kinds for photographers.

www.ephotozine.com
Online resource for news, reviews, articles, equipment.

www.equivalence.com
A site devoted to European contemporary photography.

www.festivaloflight.net
Information on photography festivals worldwide.

www.graphic-exchange.com
The archives section are a stunning showcase of photography.

www.lenswork.com
Photography and the creative process.

www.london-photographic-association.com
Membership organization, competitions, awards, opportunities and much, much more.

www.photo.net
A vast online community of photographers.

www.photoarts.com
International online photography.

www.photography.org/index.php
The Centre for Photographic Art.

www.photolucida.org
The organizers of Critical Mass.

www.photomediacenter.org
Promotes photography, digital and film.

www.photonet.org.uk
The website of the Photographers' Gallery, London.

www.photoshot.com
The world of photography on the web.

www.portfoliocatalogue.com
The Portfolio Magazine website.

www.profotos.com/education/referencedesk/masters/index.shtml
Contains information on many of the world's best-known photographers.

www.rhubarb-rhubarb.net
The International Photographic Review website.

www.sfcamerawork.org
A US-based site for contemporary photography.

www.shotsmag.com
The Shots Magazine website.

www.source.ie
Contemporary photography magazine.

www.unblinkingeye.com
A source of information and articles for film-based photographers.

www.vam.ac.uk/collections/photography/index.html
Access to the Victoria & Albert Museum photography collection.

www.zonezero.com/zz/
A large portfolio and magazine site.

Index

Acknowledgements and picture credits

Many thanks to all the contributors who have supplied images for this book. I hope that their images will inspire others as much as I've been inspired by them. Thanks also to Osman Ashraf, Tomasz Tylicki, and Sanette Blignaut for contributing such superb coursework for this project and to all my current and past students who continue to supply some seriously impressive work.

I'd also like to thank my wife Kat, my son and webmeister extraordinaire Jack, and my daughter Dixie for their wonderful support and help along the way.

Lastly but by no means leastly… to Renée Last for her incredible positivity and patience, Sarah Jameson for her dedication to the cause, David Smith for the wonderful book design, and to Brian Morris and everyone at AVA for making the whole venture possible.

Thank you one and all.

10, 126: Courtesy of Hannah Starkey; Tanya Bonakdar Gallery, New York; Maureen Paley, London.

15: Photography by Olivia Parker © 1976.

17: © Oleg Dersky www.olegdersky.com

20: © Rodchenko & Stepanova Archive, DACS 2010; Image supplied by the San Francisco Museum of Modern Art. Purchase through a gift of Robin Moll and Accessions Committee Fund: gift of Barbara and Gerson Bakar, Frances and John Bowes, Shawn and Brook Byers, Mimi and Peter Haas, Byron R. Meyer, Madeleine H. Russell and Phyllis Wattis. © Estate of Alexander Rodchenko/RAO, Moscow/VAGA, New York.

21: © Franco Fontana.

25: © Marie Pejouan.

32: © Damien Gillie.

33: © Alberto Oviedo.

37, 67: Ernst Haas/Hulton Archive/Getty images.

38, 64: © Libby Double-King 2006.

39: © National Portrait Gallery, London.

40: © Smart Photography Ltd.

41: Photography by Olivia Parker © 1977.

43: © Bryan Schutmaat 1977.

55: © Barry McCall.

59, 90: © Martine Franck/Magnum Photos.

61: © Mary Amor 2008.

61: www.rickiknights.co.uk

62: Courtesy of Gavin Ambrose.

63: © Rommert Boonstra.

64: © Vadim Tolstov.

70: © Shinichi Maruyama 2006.

73: © Costa Manos/Magnum Photos.

77, 111: © Steve Hart Photographic Ltd.

85: Collection Centre Canadien d'Architecture/Canadian Centre for Architecture, Montréal; Gift of the artist on the occasion of Phyllis Lambert's 80th birthday © Naoya Hatakeyama.

85: © Greg Funnell.

87: © Osman Ashraf.

89: © Henri Cartier-Bresson/Magnum Photos.

91: © Luka Kase.

94: © Pascal Renoux.

97: © Pen & Ink Press.

101: © Michael Levin 2005.

103: 'Handcuffs' by Oliviero Toscani (September 1989) for United Colours of Benetton.

105: © Mark Johnson.

107: © Tamas Dezso.

110–111: © 1984 The Estate of Garry Winogrand, courtesy of Fraenkel Gallery, San Francisco.

113: © James Casebere.

115: © Sanette Blignaut.

121: © Christiane Zschlommer 2005.

121: © Duncan Loughrey.

124: © Ansen Seale 2010.

129: © Tomasz Tylicki.

130: Photography by Olivia Parker © 1983.

131: © Peter Read Miller.

135, 146: © Mona Kuhn.

136: © Neil Gavin.

137: © Rut Blees Luxemburg and Union Gallery London.

143: Photography by Sandy Carson www.sandycarson.com

145: 'Newborn baby' by Oliviero Toscani (September 1989) for United Colours of Benetton.

149: © Rune Guneriussen.

153, 169: © Nikolaj Georgiew.

156: Estate Walter Peterhans, Museum Folkwang, Essen.

163: © Katie Shapiro 2008.

171: © Angus Fraser.

All reasonable attempts have been made to trace, clear and credit the copyright holders of the images reproduced in this book. However, if any credits have been inadvertently omitted, the publisher will endeavour to incorporate amendments in future editions.

All other photographs and images are courtesy of the author, Jeremy Webb: **www.jeremywebbphotography.com**

Index compiled by:
Indexing Specialists (UK) Ltd.
Indexing House
306A Portland Road
Hove
East Sussex
BN3 6LP, UK
Telephone: +44 (0)1273 416 777
Email: indexers@indexing.co.uk

Publisher's note

The subject of ethics is not new, yet its consideration within the applied visual arts is perhaps not as prevalent as it might be. Our aim here is to help a new generation of students, educators and practitioners find a methodology for structuring their thoughts and reflections in this vital area.

AVA Publishing hopes that these **Working with ethics** pages provide a platform for consideration and a flexible method for incorporating ethical concerns in the work of educators, students and professionals. Our approach consists of four parts:

The **introduction** is intended to be an accessible snapshot of the ethical landscape, both in terms of historical development and current dominant themes.

The **framework** positions ethical consideration into four areas and poses questions about the practical implications that might occur. Marking your response to each of these questions on the scale shown will allow your reactions to be further explored by comparison.

The **case study** sets out a real project and then poses some ethical questions for further consideration. This is a focus point for a debate rather than a critical analysis so there are no predetermined right or wrong answers.

A selection of **further reading** for you to consider areas of particular interest in more detail.

Ethical: awareness/ reflection/ debate

Introduction

Ethics is a complex subject that interlaces the idea of responsibilities to society with a wide range of considerations relevant to the character and happiness of the individual. It concerns virtues of compassion, loyalty and strength, but also of confidence, imagination, humour and optimism. As introduced in ancient Greek philosophy, the fundamental ethical question is: *what should I do?* How we might pursue a 'good' life not only raises moral concerns about the effects of our actions on others, but also personal concerns about our own integrity.

In modern times the most important and controversial questions in ethics have been the moral ones. With growing populations and improvements in mobility and communications, it is not surprising that considerations about how to structure our lives together on the planet should come to the forefront. For visual artists and communicators, it should be no surprise that these considerations will enter into the creative process.

Some ethical considerations are already enshrined in government laws and regulations or in professional codes of conduct. For example, plagiarism and breaches of confidentiality can be punishable offences. Legislation in various nations makes it unlawful to exclude people with disabilities from accessing information or spaces. The trade of ivory as a material has been banned in many countries. In these cases, a clear line has been drawn under what is unacceptable.

But most ethical matters remain open to debate, among experts and lay-people alike, and in the end we have to make our own choices on the basis of our own guiding principles or values. Is it more ethical to work for a charity than for a commercial company? Is it unethical to create something that others find ugly or offensive?

Specific questions such as these may lead to other questions that are more abstract. For example, is it only effects on humans (and what they care about) that are important, or might effects on the natural world require attention too?

Is promoting ethical consequences justified even when it requires ethical sacrifices along the way? Must there be a single unifying theory of ethics (such as the Utilitarian thesis that the right course of action is always the one that leads to the greatest happiness of the greatest number), or might there always be many different ethical values that pull a person in various directions?

As we enter into ethical debate and engage with these dilemmas on a personal and professional level, we may change our views or change our view of others. The real test though is whether, as we reflect on these matters, we change the way we act as well as the way we think. Socrates, the 'father' of philosophy, proposed that people will naturally do 'good' if they know what is right. But this point might only lead us to yet another question: *how do we know what is right?*

Working with ethics

You

What are your ethical beliefs?

Central to everything you do will be your attitude to people and issues around you. For some people, their ethics are an active part of the decisions they make every day as a consumer, a voter or a working professional. Others may think about ethics very little and yet this does not automatically make them unethical. Personal beliefs, lifestyle, politics, nationality, religion, gender, class or education can all influence your ethical viewpoint.

Using the scale, where would you place yourself? What do you take into account to make your decision? Compare results with your friends or colleagues.

Your client

What are your terms?

Working relationships are central to whether ethics can be embedded into a project, and your conduct on a day-to-day basis is a demonstration of your professional ethics. The decision with the biggest impact is whom you choose to work with in the first place. Cigarette companies or arms traders are often-cited examples when talking about where a line might be drawn, but rarely are real situations so extreme. At what point might you turn down a project on ethical grounds and how much does the reality of having to earn a living affect your ability to choose?

Using the scale, where would you place a project? How does this compare to your personal ethical level?

01 02 03 04 05 06 07 08 09 10

01 02 03 04 05 06 07 08 09 10

Your specifications
What are the impacts of your materials?

In relatively recent times, we are learning that many natural materials are in short supply. At the same time, we are increasingly aware that some man-made materials can have harmful, long-term effects on people or the planet. How much do you know about the materials that you use? Do you know where they come from, how far they travel and under what conditions they are obtained? When your creation is no longer needed, will it be easy and safe to recycle? Will it disappear without a trace? Are these considerations your responsibility or are they out of your hands?

Using the scale, mark how ethical your material choices are.

Your creation
What is the purpose of your work?

Between you, your colleagues and an agreed brief, what will your creation achieve? What purpose will it have in society and will it make a positive contribution? Should your work result in more than commercial success or industry awards? Might your creation help save lives, educate, protect or inspire? Form and function are two established aspects of judging a creation, but there is little consensus on the obligations of visual artists and communicators toward society, or the role they might have in solving social or environmental problems. If you want recognition for being the creator, how responsible are you for what you create and where might that responsibility end?

Using the scale, mark how ethical the purpose of your work is.

01 02 03 04 05 06 07 08 09 10

01 02 03 04 05 06 07 08 09 10

Working with ethics

One aspect of photography that raises an ethical dilemma is that of inherent truth or untruth in manipulating images, particularly with the use of digital cameras. Photographs have, arguably, always been manipulated and at best they represent the subjective view of the photographer in one moment of time. There has always been darkroom manipulation through retouching or double exposures, but these effects are far easier to produce digitally and harder to detect. In the past, the negative was physical evidence of the original, but digital cameras don't leave similar tracks.

While creative photography might not set out to capture and portray images with the same intent that documentary photography might, is there an inherent deception in making food look tastier, people appear better looking or resorts look more spacious and attractive? Does commercial image manipulation of this kind set out to favour the content in order to please, or is it contrary to public interest if it results in a purchase based on a photograph that was never 'the real thing'? How much responsibility should a photographer have when the more real alternative might not sell?

Bernarr Macfadden's *New York Evening Graphic* was dubbed 'the Porno Graphic' for its emphasis on sex, gossip and crime news. In the early 1920s, Macfadden had set out to break new ground and publish a newspaper that would speak the language of the average person. One of the paper's trademark features was the creation and use of the composograph. These were often scandalous photographic images that were made using retouched photo collages doctored to imply real situations. The most notorious use of the composograph was for the sensational Rhinelander divorce trial in 1925.

Wealthy New York socialite Leonard Kip Rhinelander married Alice Jones, a nursemaid and laundress he had fallen in love with. When word got out, it was one of high society's most shocking public scandals in generations. Not only was Alice a common maid, it was also revealed that her father was African American. After six weeks of pressure from his family, Rhinelander sued for divorce on the grounds that his wife had hidden her mixed-race origins from him. During the trial, Jones's attorney had requested that she strip to the waist as proof that her husband had clearly known all along that she was black.